CEN

FEJFER, Jane

733.5

THE INCE BLUNDELL
COLLECTION.

Please return this book

COLLEC

D1381258

CEN

FEJFER, Jane

733.5

THE INCE BLUNDELL
COLLECTION.

Please return this book

COLLEC

STEVENAGE CENTRAL
LIBRARY
GOVERNMENT PUBNS
COLLECTION

THE INCE BLUNDELL COLLECTION OF CLASSICAL SCULPTURE

VOLUME I – THE PORTRAITS

PART 1:

INTRODUCTION

THE FEMALE PORTRAITS

CONCORDANCES

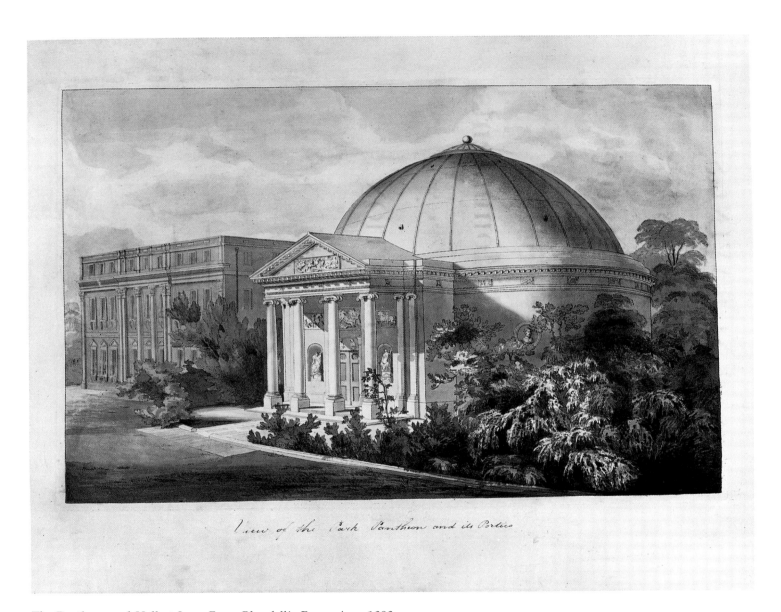

View of the Park Pantheon and its Portico

The Pantheon and Hall at Ince. From Blundell's Engravings 1809.

STEVENAGE CENTRAL
LIBRARY
GOVERNMENT PUBLIS
COLLECTION

The Ince Blundell Collection
of Classical Sculpture

VOLUME I – THE PORTRAITS

Part 1

INTRODUCTION · THE FEMALE PORTRAITS · CONCORDANCES

Jane Fejfer & Edmund Southworth
Photographs by David Flower
on behalf of the Board of Trustees
of the National Museums & Galleries
on Merseyside

LONDON : HMSO

This Volume is Equivalent to:
CORPUS SIGNORUM IMPERII ROMANI
CORPUS OF SCULPTURES OF THE ROMAN WORLD
GREAT BRITAIN.
Volume III Fascicule 2

© Copyright Controller of HMSO 1991
First published 1991

ISBN 0 11 290480 7

Designed by HMSO Graphic Design

British Library Cataloguing in Publication Data

A CIP catalogue record for this book is available from the
British Library

Contents

This work is dedicated
to the memory of
Bernard Ashmole, b.1894,
who died on
25th February 1988.

Foreword

The Trustees of the National Museums and Galleries on Merseyside were established in 1986 to administer the collections formerly owned by the Merseyside County Council. It is the policy of the Trustees to make those collections available to the public and the scholar in the most appropriate way. There are three major groups of classical sculpture in their care. The Hope sculptures at the Lady Lever Art Gallery, published by Geoffrey Waywell in 1987, and the Nelson collection at Liverpool Museum, which includes an important group formerly in the collection of Lord Kinnaird of Rossie Priory, are the smaller of these groups. The third collection, that made by Henry Blundell between 1777 and 1809, is by far the largest collection of classical sculpture in Britain outside the British Museum. It was generously donated to the Liverpool Museum and the Walker Art Gallery by Sir Joseph Weld in 1959 when with the sale of Ince Blundell Hall it became impossible to retain the collection *in situ*.

The Ince Blundell Research Project is being undertaken with the assistance of the University of Liverpool and this publication is the first part of Volume One which will include all the portraits in the collection. We are especially grateful to Jane Fejfer, research fellow at the Institute of Archaeology at the University of Copenhagen, for undertaking this part of the work. The introduction and concordance in this volume has been prepared by Edmund Southworth, the Curator of the Department of Archaeology and Ethnology at Liverpool Museum, who is co-ordinating the project for the National Museums and Galleries on Merseyside. Our most grateful thanks are due to the Carlsberg Foundation whose continued support has made Jane Fejfer's work possible, and to the Ny Carlsberg Foundation and the Danish Research Council who have also generously contributed to her work.

Richard Foster:
Director, National Museums & Galleries on Merseyside

Prof. John Davies:
Department of Classics & Archaeology, University of Liverpool

Prof. Ingrid Strøm:
Institute of Prehistoric & Classical Archaeology, University of Copenhagen

Acknowledgements

Our most grateful thanks are due to Geoffrey Waywell of Kings College, London, for his support for this project and his comments on the text. Ingrid Strøm of the Institute of Prehistoric and Classical Archaeology of the University of Copenhagen has offered much support, advice and assistance. Our thanks are also due to Niels Hannestad, Flemming Johansen, Hans-Erik Matthiesen, Torben Melander, Mette Moltesen, Hans-Georg Oehler, Rolf Schneider, and Jan Zahle. At the National Museums and Galleries special thanks are due to Piotr Bienkowski, Richard Foster, Eric Greenwood, Rebecca Lang, Edward Morris, Fiona Neale, Patrick O'Hare, Fiona Philpott, Philip Phillips, Keith Priestman, and Ray Wadsworth. David Flower deserves particular mention for the photography which was often done under difficult circumstances. At Liverpool University, much assistance has been given by Prof. J. K. Davies, Chris Mee, Prof. A.F. Shore, and many other friends and colleagues. Glenys Davies, and Gerard Vaughan contributed many valuable comments and suggestions.

Reverend Mother and the Community at Ince Blundell Hall have made us very welcome on our visits there and we are grateful for their continued interest. Sir Joseph Weld O.B.E. and Mr. Wilfred Weld Esq. at Lulworth have very kindly made their collections available to us.

Our respective spouses, Palle and Helen, must also accept our gratitude for their part in the production of this work.

Jane Fejfer, Darmstadt

Edmund Southworth, Liverpool

List of Illustrations

Abbreviations

Abbreviations not found below follow *Archäologische Bibliographie*

Amelung, *Vat. Kat.* I-III	W. Amelung, *Die Skulpturen des Vaticanischen Museums*, vols.I-III, Berlin 1903–1908
Antikensamm-lungen im 18. Jahrhundert	Antikensammlungen im 18. Jahrhundert, ed. H. Beck, P.C. Bol, W. Prinz, H.v. Steuben. *Frankfurter Forschungen zur Kunst.* Vol.9, Berlin 1981
Ashmole	B. Ashmole, *A Catalogue of the Ancient Marbles at Ince Blundell Hall*, Oxford 1929
Ashmole *Guide*	B. Ashmole, *A short guide to the collection of ancient marbles at Ince Blundell Hall*, with historical notes on Ince Blundell Hall and the Weld Blundell family by Captain G. F. Weld Blundell, Oxford 1950
Bernoulli I-III	J.J. Bernoulli, *Römische Ikonographie*, vols.I-III, Stuttgart 1882–1899
Blümel RB	C. Blümel, *Katalog der antiken Skulpturen im Berliner Museum. Römische Bildnisse*, Berlin 1933
Blundell Acc.	*An Account of the Statues, Busts, Bass-Relieves, Cinerary Urns, and other Ancient Marbles and Paintings at Ince. Collected by Henry Blundell*, Liverpool 1803
Blundell Eng.	*Engravings and Etchings of the Principal Statues, Busts, Bass- Reliefs, Sepulchral Monuments, Cinerary Urns etc., in the Collection of Henry Blundell, Esq. at Ince*, vols.I-II, Liverpool 1809–10
BMC Coins	H. Mattingly, *Coins of the Roman Empire in the British Museum*, vols.I-IV, London 1923–62
Calza, *Ostia. I Ritratti*	R. Calza, *Scavi di Ostia V. I Ritratti. Parte I*, 1964
Clarac	Le Comte F. de Clarac, *Musee de Sculpture Antique et Moderne*, vols.I-V, Paris 1826–53
DAI Inst. Neg.	Deutsche archäologische Institut, Rome, Negative Number

Fittschen, *Erbach*	K. Fittschen, *Katalog der antiken Skulpturen in Schloss Erbach*, Berlin 1977
Fittschen, *Bildnistypen*	K. Fittschen, *Die Bildnistypen der Faustina Minor und die Fecunditas Augustae*, Göttingen 1982
Fittschen/ Zanker	K. Fittschen and P. Zanker, *Katalog der Römischen Porträts in den Capitolinischen Museum und den anderen kommunalen Sammlungen der Stadt Rom. I. Kaiser-und Prinzenbildnisse*, Mainz 1985 *III. Kaiserinnen-und Prinzessinnenbildnisse, Frauenporträts*, Mainz 1983
Geschichter	H. Jucker and D. Willers, *Geschichter. Griechische und römische Bildnisse aus Schweitzer Besitz*, Berne 1983
Howard	S. Howard, *Bartolomeo Cavaceppi. Eighteenth-Century Restorer*, London 1982
Inan/Alföldi-Rosenbaum	J. Inan and E. Alföldi-Rosenbaum, *Römische und frühbyzantinische Porträtplastik aus der Türkei*, Mainz 1979
Mansuelli, *Galleria Uffizi*	G.A. Mansuelli, *Galleria degli Uffizi. Le Sculture*, vols.I-II, Rome 1958–1961
Meischner, *Diss*	J. Meischner, *Das Frauenporträts der Severerzeit*, Diss. Berlin 1964
Michaelis	A. Michaelis, *Ancient Marbles in Great Britain*, Cambridge 1882
Michaelis, *Priv.*	A. Michaelis, "Die Privatsammlungen antiken Bildwerke in England", in *Archäologische Zeitung* 32 (1874) p.1 ff.
Oehler, *Foto*	H. Oehler, *Foto und Skulptur. Römische Antiken in englischen Schlössern*, Cologne 1980
Picon, *Cavaceppi*	C. Picon, *Bartolomeo Cavaceppi. Eighteenth century restoration of ancient marble sculpture from English private collections.* Exhibition Clarendon Gallery, London 1983
Poulsen	F. Poulsen, *Greek and Roman Portraits in English Country Houses*, Oxford 1923

Reinach-Clarac	S. Reinach, *Repertoire de la Sculpture Greque et Romaine*, vol. I, Clarac de Poche, Paris 1897
Stuart Jones	H. Stuart Jones, *A Catalogue of the Ancient Sculptures preserved in the Municipal Collections of Rome. The Sculptures of the Museo Capitolino*, Oxford 1912
Vermeule/ von Bothmer	C. Vermeule and D. von Bothmer, "Notes on a new Edition of Michaelis. Part III", in *AJA* 63 (1959) p.139 ff.
WAG Catalogue	*Walker Art Gallery, Liverpool. Foreign Catalogue*, compiled by E. Morris and M. Hopkinson, London 1977
Wegner, *Herrscherbild Ant. Zeit*	M. Wegner, *Die Herrscherbildnisse in antoninischer Zeit. Das römische Herrscherbild II 4*, Berlin 1939
Wegner, *Herrscherbild Caracalla*	M. Wegner and H.B. Wiggers, *Caracalla bis Balbinus. Das römische Herrscherbild III 1*, Berlin 1971
Wegner, *Herrscherbild Die Flavier*	M. Wegner and G. Daltrop and U. Hausmann, *Die Flavier. Das römische Herrscherbild II 1*, Berlin 1966
Wegner, *Herrscherbild Hadrian*	M. Wegner, *Hadrian. Das römische Herrscherbild II 3*, Berlin 1956
Wegner, *Vz. I*	M. Wegner, "Verzeichnis der Kaiserbildnisse von Antoninus Pius bis Commodus. I", in *Boreas* 2 (1979) p.87 ff.
West	R. West, *Römische Porträt-Plastik*, vols.I-II, Munich 1933
Wrede, *Consecratio*	H. Wrede, *Consecratio in Formam Deorum*, Mainz am Rhein 1981
Wyndham, *Petworth*	M. Wyndham, *Catalogue of the Greek and Roman Antiquities in the Possession of Lord Leconfield*, London 1915

The Ince Blundell Research Project

This project commenced in 1984 and is a joint venture between the National Museums and Galleries on Merseyside, the University of Liverpool and the University of Copenhagen. Work on the project is jointly supervised by Richard Foster, Director of the National Museums and Galleries on Merseyside, and Prof. J. K. Davies of the Dept. of Classics & Archaeology of the University of Liverpool. Prof. Ingrid Strøm of the Institute of Prehistoric and Classical Archaeology in Copenhagen has played a particularly valuable role in supervising Jane Fejfer's work in this first volume. Edmund Southworth is the project coordinator at Liverpool Museum.

The first phase of the project was to enhance the raw material for the scholar in the form of a computerised database of the collection. This volume contains a synthesis from this in the form of a concordance. It was agreed from the start that the project would have as its aim the comprehensive re-cataloguing and re-publication of the collection. Despite Ashmole's aim that his volume should only be a starting point for future work, no complete examination of the collection had taken place since 1922. In any case his volume was over half a century old, increasingly difficult to find outside specialist libraries, and did not meet modern standards of illustration and analysis. As the 1803 Account originally listed some 553 items and the collection eventually reached 599 items, it became clear that complete cataloguing and publication would inevitably require the preparation of several volumes. There was the added concern to achieve descriptions which were as objective as possible. This meant allowing the scholar to spend considerable time with the actual objects and only after this working with photographs.

The publication is therefore to be divided into several volumes with different scholars undertaking sections of the work. The following division of the volumes is planned.

Volume 1. Part 1: Introduction (by Edmund Southworth). The Female Portraits (by Jane Fejfer). Concordance (by Edmund Southworth).
Part 2: Male Portraits (by Jane Fejfer).

Volume 2. Ash Chests.

Volume 3. Statuary – life-size and miniature.

Volume 4. Reliefs and sarcophagi.

Volume 5. The history of the collection in the context of the 18th-century antiquities market. The modern pieces.

The volume on the Ash Chests is being prepared by Dr. Glenys Davies of the University of Edinburgh. This will include 61 pieces. It was felt that this was a coherent group of items for study and could be separated initially from the other funerary pieces.

Volume 5 will be undertaken by Dr. Gerard Vaughan of the University of Oxford. With the assistance of the Leverhulme Foundation, he has already prepared a short survey of the documentary evidence relating to the collection. The absence of a family archive has been a serious impediment to direct research but it has been possible to identify groups of documentary material elsewhere that cast light on the history of the sculptures. Henry Blundell acquired sculpture from the main contemporary Italian sources as well as from secondary English sales, and so it will be appropriate to try and view his activity in the wider context of the extensive trade in antiquities in the later years of the 18th century in Rome. Biographical details of Henry Blundell will also be included in this volume, together with a discussion of the modern pieces in the collection.

INTRODUCTION

The Ince Blundell Collection

The majority of the collection of classical sculptures originally at Ince Blundell Hall in Lancashire has been in the care of the public museum and gallery in Liverpool since 1959. Prior to this they had remained in private hands in their original setting at Ince. Unlike so many other collections from English Country Houses, the Ince collection has survived relatively intact without any attempt to sell or disperse it. This brief introduction explains how the collection was assembled, documented and displayed by Henry Blundell. It also describes the history of the collection from the death of its founder to the present day.

The Blundell family of Ince Blundell Hall in Lancashire was one of the oldest in the region. Blundells have been in England since the Norman conquest and a Richard Blundell appears in the late 12th century at Ince as a witness to local charters[1]. The village of Ince itself, mentioned in Domesday, becomes known as Ince Blundell in the 14th century and there is still a 14th-century hall on the estate. From the 16th to the 18th centuries the family suffered persecution for its Catholic faith but remained a significant force in the county with wide property interests and social contacts. The last member of the family to be threatened with prosecution for recusancy was Robert Blundell. He gained possession of a large estate in Lydiate, near Ince, in 1760 and soon afterwards retired to Liverpool where he died in 1773[2].

In 1761 Robert Blundell had transferred the family estate at Ince with half its income to his son Henry who was then aged 37. (*Figure 1.*) After a relatively frugal few years, Henry married and his financial affairs improved dramatically. Several years later Henry's income virtually doubled as the rents from his mother's family estates elsewhere in Lancashire devolved to him. He now invested considerable energy and resources into improving his estates, set in rich agricultural land. A new Hall had only recently been completed by his father, but there was still much to be done:

"Soon after (the income from the Lostock estates had added to his income) I had fitted up all the apartments in the house, built a large body of offices without the assistance of a Wyat or any architect. I made also a new garden with stoves, a greenhouse & hot walls. &nd in a few years after I made exchanges of land with the late Lord Sefton of above 200 acres which enables me to build the Park wall, make several new buildings & a great variety of new plantations in all which I spared no labour, rising mostly at five in the morning and out most of the day with the workmen"[3].

Clay for the bricks for the park wall came from excavations in the park which were then turned into an ornamental lake, the whole process providing work for the local population. Blundell's wife Elizabeth had died in 1767 and this may have been the reason for such a whole-hearted approach to his work. By 1776, at the age of 52, he had completed work on the estate and was possibly looking around for a new interest in life.

It was a fellow member of the Catholic landed gentry in Lancashire who introduced Henry Blundell to sculpture. Charles Townley, from Towneley Hall near Burnley, had, like Blundell, been educated in the Classics by the Jesuits in France, a common practice in Catholic families at this time. Townley made his first Italian Grand Tour in 1767–8, followed by a second in 1771–4, during which time he laid the foundations of his vast collection of classical antiquities, including not only marble sculptures but also bronzes, painted vases, gems and coins[4]. This collection received considerable public attention and it is

1. *Victoria County History of Lancashire, Vol.III* (1907) pp. 78–85. The Blundell family history is reasonably well documented through the Medieval period, showing a gradual accretion of land and wealth.
2. Baines, *History of the County Palatine & Duchy of Lancaster, Vol. II* (1870) p.395.
3. For basic biographical material see *Dictionary of National Biography*, vol II, pp 727–8. Also Ashmole *Guide*. Also Blundell "A letter to a Friend" Feb. 10th 1808. Private coll.
4. For the Townley collection see J. Dallaway, *Anecdotes of the Arts in England* (1800) pp.229–236; Sir Henry Ellis, *The Townley Gallery* (1846) i, pp.1–13; B. F. Cook and G. Vaughan (forthcoming).

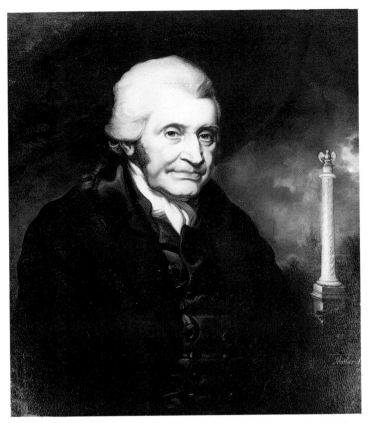

Figure 1. *Portrait of Henry Blundell as an old man by Mather Brown, c.1800.*

The list of sources for the collection is impressive[9]. As well as the Villas D'Este & Mattei, there are pieces from the villas of Altieri, Borioni, Capponi, Lante & Negroni. Dealers and restorers included Albacini, Boni, Cavaceppi, Antonio D'Este, Gavin Hamilton, Thomas Jenkins, Lisandroni, Pacetti, La Piccola, Piranesi and Volpato[10]. As his agent in Rome, Blundell engaged a Jesuit priest called Thorpe who worked closely with Jenkins and was thus in the mainstream of the Italian Market[11].

Blundell was a regular purchaser over the next 30 years. There was an initial period of activity in the 1770s and 1780s which then declined as the supply of sculpture from Italy dried up[12]. By 1800 he was buying from collections already in England. In May 1800 45 chests of art and antiquities were sold at

5. Various, e.g. a copy of "Elegantiores Statuae Antiquae" 1776, inscribed "Henry Blundell Rome 16th Sep. 1777", and now in the Walker Art Gallery. See note 3 above.

6. Blundell Acc. no.49. Townley is consistently referred to in correspondence and in the published works as "a friend".

7. For the Villa D'Este see Thomas Ashby, "The Villa d'Este at Tivoli and the Collection of Classical Sculptures which it contained", *Archaeologia*, LXI (1908) pp.219–56.
 For the Villa Mattei see L. Hautecoeur, "La Vente de la Collection Mattei et les Origins du Musee Pio-Clementini", in *MEFRA* 30 (1910) p.57 ff.

8. For a discussion of the 18th-century art market in Rome see F. Haskell and N. Penny, *Taste and the Antique. The Lure of Classical Sculpture, 1500–1900*, London (1982) p.317 ff. See also G. Vaughan, "Henry Blundell's Sculpture Collection at Ince Hall", in "Patronage & Practice – Sculpture on Merseyside", ed. P. Curtis Liverpool (1989) pp.13–21, and forthcoming in this series.
 For a discussion of the English collectors and their requirements see Dirk Kocks, *Antikenaufstellung und Antikenergänzung im 18. Jahrhundert in England*, in Antikensammlungen im 18. Jahrhundert.

9. Michaelis, p.334. The source for each piece is given by Blundell in his Account where he considers it significant.

10. Blundell Acc. Also references in correspondence, e.g. letter from Henry Blundell to Charles Townley 2nd January 1787, "I looked over all ye articles at Volpato's you mentioned in a letter to be worth my notice but I found their restors horrid . . .", and, in the same letter, "I will enclose a small sketch also of La Picola's Satyr & hermaphrodite, with ye inscription on its plynth as mentioned."
 Correspondence between Blundell and Townley referred to in this and subsequent notes is now the property of the Hylas Charitable Foundation.

11. "He had resided there many years and was the most intelligent in the line of vertu I ever met with. He was of the greatest service to me in purchasing many valuable marbles & paintings, & when I was in England sent me drawings of such things as were on sale and which he thought worth my attention." See note 3 above.
 As well as collecting in Rome for Blundell, John Thorpe also collected for Thomas Weld of Lulworth and for the eighth Lord Arundell of Wardour who were both building chapels at that time. Correspondence to his Jesuit colleagues survives (information from the Rev. T. G. Holt S.J.). For Wardour and Thorpe see *Country Life*, October 1968.

12. E.g. letter from Henry Blundell to Charles Townley 2nd January 1787, "There is no doubt that few good things are seldom to be met with on sale in Rome."

not surprising to see Blundell being inspired by Townley when they joined up in Rome late in 1776. They spent considerable time together in Rome and Naples, "visiting the curious museum cabinets & curiosities of that country"[5]. In 1777 Blundell made his first purchase of classical sculpture, a statuette of Epicurus (Ince no.49) (*Figure 2*), which was "much recommended by a friend"[6], presumably Townley.

The two men were in Rome when large amounts of sculpture from the Villas D'Este and Mattei came onto the market. Whilst the finest pieces had already found their way into important Roman collections[7], there was still an opportunity for Blundell to acquire a substantial collection of other well-known pieces with a minimum of effort. The core of his future collection came from these two villas and the experience seems to have stimulated his desire to collect almost to the level of obsession. From 1777 till 1810 he acquired sculpture on a prodigious scale. Through Townley he had immediate access to the network of agents and dealers operating in England and Rome at this period. These could supply reproductions of ancient marbles, modern depictions of classical figures, ancient works restored for the English taste, or the original, untouched fragment[8].

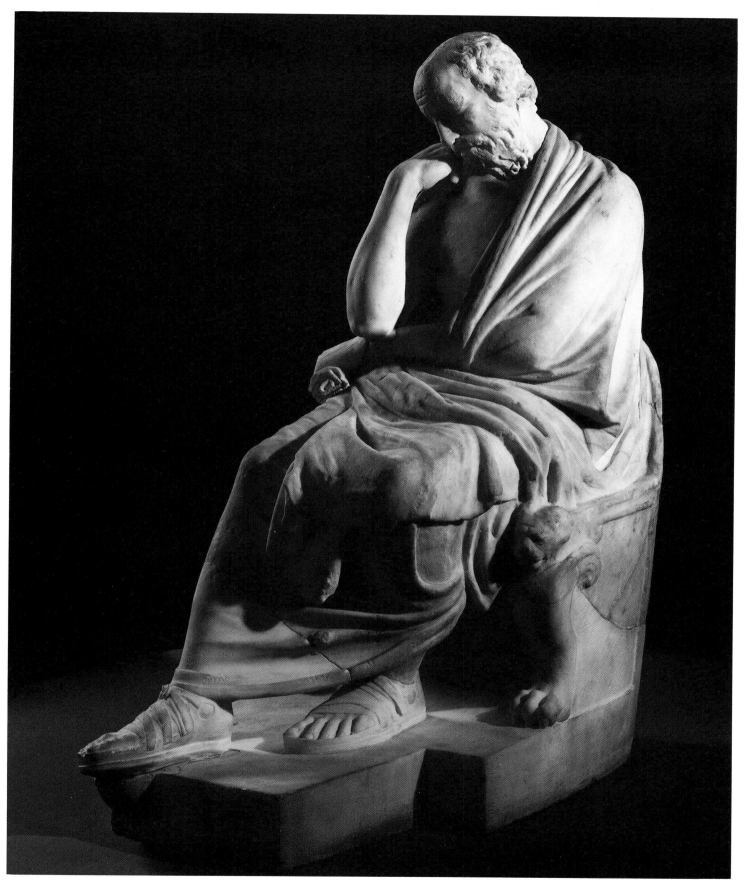

Figure 2. *Statuette of Epicurus. Ince 49.*

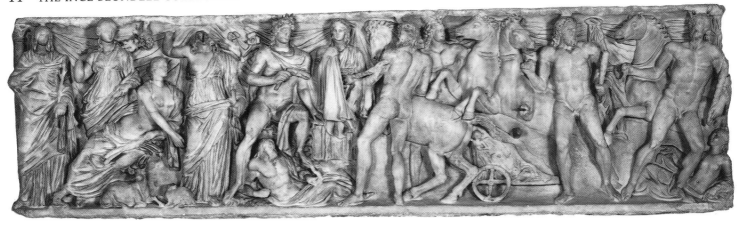

Figure 3. *Sarcophagus relief, Phaeton before Helios. Ince 523.*

auction in London by Christies[13]. These had been pillaged from the Pope's apartments by the French but intercepted on the sea passage back to France. Blundell bought ten specimens, but the price of one particularly grieved him. This was the front of a sarcophagus of the late 2nd century AD. depicting Phaeton imploring his father Helios to lend him his sky-chariot (Ince no.523) (*Figure 3*). When the piece came out of the Villa D'Este many years earlier it had been heavily encrusted with mineral salts due to its use as a fountain. Blundell bought it at that stage, paying ten pounds for it. Cleaning revealed it to be a splendid piece and it became the subject of conversation in Rome as an interesting find. The Pope heard about it through his antiquarian and advisor, Visconti, and asked that it stay in the city. A loyal Catholic like Blundell could hardly refuse, but the Pope made amends by giving him five marble topped tables to take home instead. The subsequent appearance of the piece on the English market was a good opportunity to regain possession, but the price he now had to pay was 260 guineas[14]. Despite his chagrin at the price, it did not worry him unduly. "You may think me extravagant," he wrote to his brother-in-law in 1801, "but if I lay out 1000 pounds it is no great affair to me: the money is no object"[15].

In June 1800 he bought eight pieces at Lord Cawdor's sale[16], in April 1801, 22 pieces from Lord Bessborough at Roehampton[17], and in May 1802, seven from Lord Mendip[18]. Blundell's Account, published in 1803 ends with this last group at the number 553. A further source was the workshop of the sculptor Thomas Banks from which an unknown number of pieces came after that sculptor's death. One major piece is a life-size seated figure, originally from the Arundel collection, which spent over a century in

the River Thames after falling overboard during its original shipment. When dredged nearer the shore, a metal ring was attached and it was used by local fishermen as a mooring point[19].

By the time of his death Blundell had acquired a collection of sculpture in marble and bronze as well as gems, mosaics and glass numbering 599 pieces in total. Over 400 of the sculptures were ancient. In numerical terms it therefore compared with the Townley collection bought by the British Museum in 1805[20]. After this date it was certainly the largest in England in private hands. His motives for collecting are unclear. At the beginning of his collecting activity he purchased a number of modern pieces[21]. At no time does he ever imply that they are anything other

13. "A Catalogue of a small Assemblage of Capital and Valuable MARBLES recently Consigned from ITALY . . .", Mr. Christie, 31st May 1800, Pall Mall, London.
14. Blundell Acc. pp.179–180.
15. Information from the Stonor papers, courtesy the Dowager Lady Camoys, quoted D. Sutton, *"The Lure of the Antique"*, *Apollo Magazine* (1984) p.324.
16. "A Catalogue of a most Noble, Capital, and Valuable Collection of ANTIQUE MARBLE STATUES AND BUSTEOS. . . the property of the Right Hon. Lord Cawdor . . .", Messrs. Skinner & Dyke, 5th & 6th June 1800, London.
17. "A Catalogue of the Capital, Well-known, and Truly Valuable Collection of Antique Statues, Bustos, Aegyptian and Other Vases, Bas-reliefs etc . . .", Mr. Christie, 7th April 1802, at Roehampton.
 Correspondence between Townley in March and April 1802 confirms that Townley was acting for Blundell at the sale. Blundell had also asked "Westmacott Jnr." to bid for two pieces, to the obvious irritation of Townley.
18. "A Catalogue of the Capital and Singularly valuable Collection of Antique Marbles, Statues, Bustos, etc. at the Distinguished Villa of the late Rt. Hon. Lord Mendip . . .", Mr. Christie, 17th May 1802, at Twickenham, Middlesex.
19. Michaelis no.64, pp.356–7.
20. See A.H. Smith, *A catalogue of Sculpture in the Department of Greek and Roman Antiquities, British Museum*, 3 vols. (1892–1904).

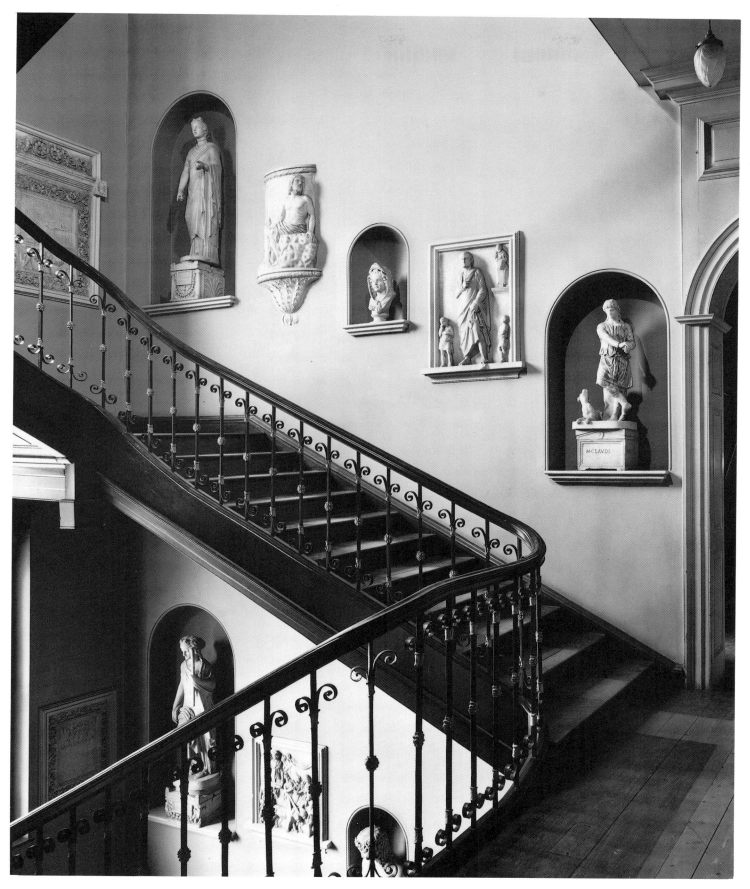

Figure 4. *Interior view of Hall showing staircase, 1959.*

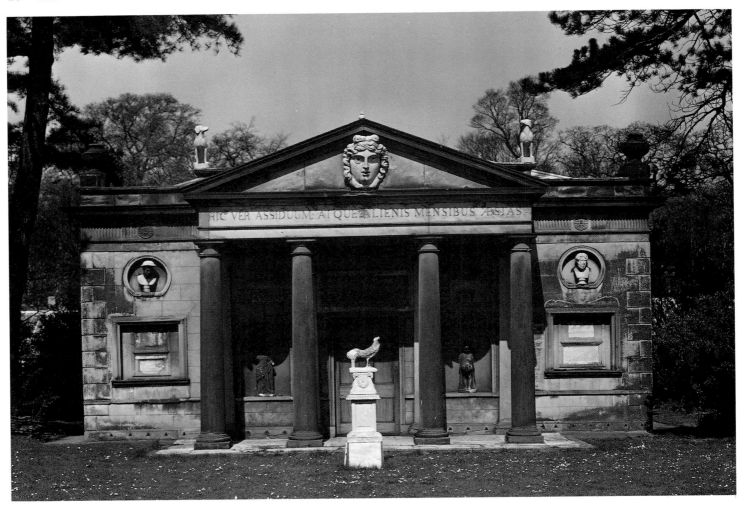

Figure 5. *The Garden Temple. Exterior view, 1959.*

than representations of classical deities or historical figures. He knew how restorers worked[22] and whilst he would probably have been taken in by some of the best forgeries, there are few of these in the collection and most of the modern pieces are obvious. A simple explanation is that he was interested in the sculptures for the classical ideas that they represented and was not unduly worried initially whether a piece was ancient or not.

It could be argued that part of Blundell's desire to collect sculpture was simply to add to the decoration and furnishings of the house at Ince in a manner fashionable at the time[23]. It is significant therefore to consider the arrangement of sculpture at the Hall. The bulk of the decoration, plaster mouldings etc. of the 1740 building had revolved around the paintings of the Hall and there were no subsequent dramatic changes to the main rooms to cope with the new influx of sculpture. It was to be found mainly embed-

ded in the walls of the stairs and corridors within the house (*Figure 4*). A building in the style of a classical temple later housed the first large group of reliefs and free standing material collected in the 1770s and 1780s which spilled over from the house[24] (*Figures 5 & 6*). The arrangement of niches and alcoves to present the reliefs and statues to best advantage is a fairly standard Neo-classic design. Whilst a Liverpool architect, Everard, has been mentioned in connection with the Temple[25], we have no real evidence and it may be that Blundell himself was closely involved with the design and construction, as he had been with two earlier ornamental gateways in the park wall and other buildings on the estate.

The Garden Temple was superseded by a scaled down version of the Pantheon in Rome as the main display gallery at Ince. This circular, domed building was planned in 1801, started the following year, but only completed shortly before his death in 1810.

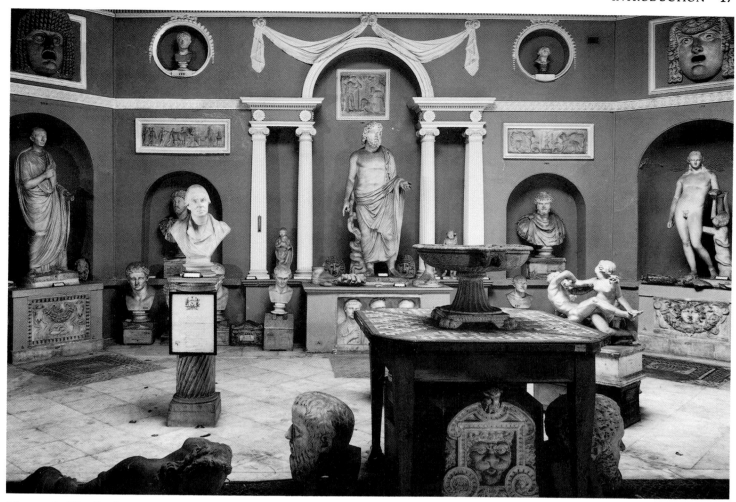

Figure 6. *The Garden Temple: Interior view, 1959.*

21. E.g. Ince nos. 99, 100 and 101. Blundell Acc. pp.45–6.
 "*XCIX. Jupiter Serapis . . . It is a copy by Jos. Angelini, a noted sculptor at Rome, from that fine antique head of Jupiter in the Vatican Museum . . . It was bought from Volpato the Engraver, with the pillar it stands on.*
 "*C. Lucius Verus. In the Borghese villa at Rome are two very beautiful busts of this personage, from one of which this is a copy, by Carlo Albacini.*
 "*CI. Minerva. A copy from that much admired antique bust of Minerva at Rome, by the aforesaid artist . . . The original is reckoned the finest head of that Goddess extant; of which this is an excellent copy, without the least flaw in the marble. It stands on a pillar of red granite, and was bought from Carlo Albaccini, 1777, with the above.*"

22. E.g. Blundell Acc. pp.91–2, about an antique vase Ince no.270 which "was so much decayed and corroded that it was necessary to re-work several parts and new polish the figures; this gave it the appearance of being modern which lessens the value of it. It was bought from Volpato; the pedestal and repairs by Piranesi."
 Various items of correspondence show his caution in purchasing restored pieces e.g. to Charles Townley 2nd January 1787, "But I always suspect these gentlemens tricks and contrivances."

23. See for example H.G. Oehler, "Das Zustandekommen einiger englischen Antikensammlungen im 18. Jahrhundert", in Antikensammlungen in 18. Jahrhundert p.295 ff.

24. Letter from Henry Blundell to Charles Townley 2nd January 1787, "But I have now made my markets and have no room in my house for any more paintings or sculpture." By January 1791 work was under way and the display was complete by 1792. It may well have been a conversion of one of the garden buildings put up by Blundell himself before 1776. Until recently it was still connected to the heating system of the garden structures.

25. H.M. Colvin, *Biographical Dictionary of English Architects* (1978) p.726.

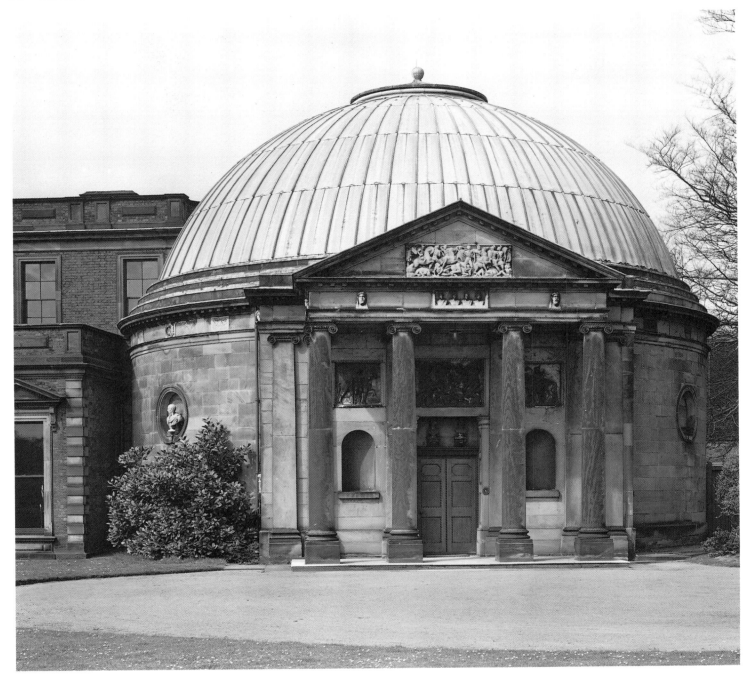

Figure 7. *The Pantheon. Exterior view, 1959.*

Initially separate from the Hall but linked by a corridor, it was later joined to the main structure by the insertion of a large dining room in 1847. The Pantheon was designed and modelled in wood as well as on paper and Blundell was asking Townley to bear the dimensions in mind when attending the sale of the Bessborough collection[26]. The internal arrangement appeared to stay virtually as Blundell assembled it throughout the 19th and 20th centuries (*Frontispiece, Figures 7 & 8*).

26. Letter Henry Blundell to Charles Townley 23rd March 1801,
 "In your late letter you say you shd judge better what marbles out of Lord Besboroughs collection wd best suit, if you know the size, plan and situation of my intended room; it about 37 feet inside diameter, circular, lighted from the top, as the Pantheon . . .; the walls 6 feet thick to get room for 4 large recesses, so as to be able to see round the principal statues; nothing is yet done about it, but on paper except a model in wood just put in hand. In the 4 other smaller recesses I shall place the 4 tables I bt last year at London; and placed on them smaller statues etc."

The Pantheon is discussed in most publications on Neo-classical architecture, the most recent being D. Stillman, *English Neo-classical Architecture*, Vol.1 (1988).

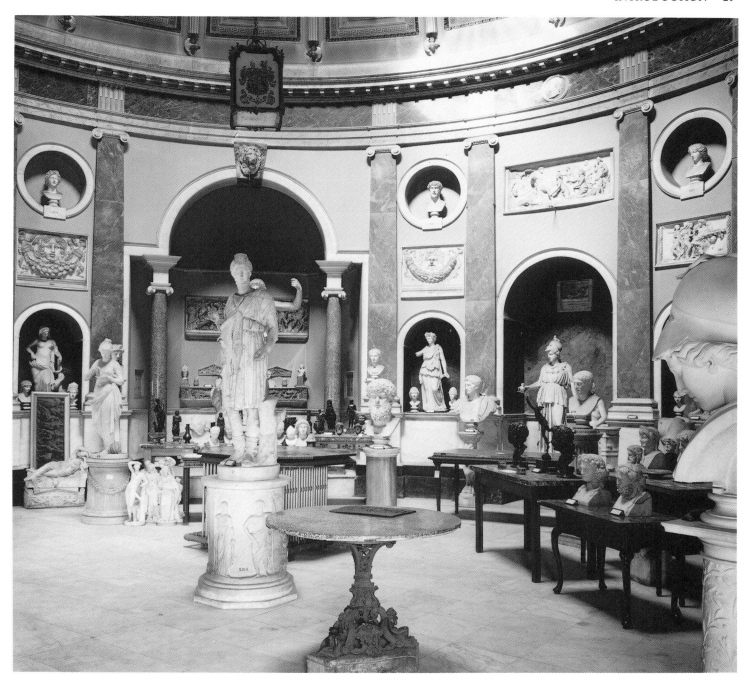

Figure 8. *The Pantheon. Interior view, 1959.*

Henry Blundell's Publication of the Collection

Henry Blundell was an astute collector and a sensible man even though we have little evidence to class him as a scholar. He had two works privately printed on the collection, both of which he compiled. In 1803 his "Account . . ." lists the 553 pieces acquired up to May 1802 with details of source and anecdotes about the history of individual pieces. These are blended with comments on ancient history or classical mythology to put the sculpture into context for the reader. (In the subsequent catalogue entries in this volume the appropriate entry in the Account is transcribed at the beginning of the notes.) Many of the details are repeated and occasionally enhanced in 1809–10 in a two volume collection of 150 engravings of the finest pieces and several pieces acquired since 1802. The inspiration for this major work had come from Townley, Blundell having intended only to produce

a catalogue for his friends, but his illness and sub-sequent death then delayed its publication. Several of the engravings had been done in Rome and were possibly to advertise the pieces on the market there as they include rather optimistic hypothetical resto-rations. The remainder of the illustrations are of vary-ing quality and were done in Liverpool and London over a lengthy period from 1798. Blundell selected items he thought important whilst Townley made the final choice and arranged to have the engravings

made, paying the artists and billing Blundell. The compilation of the drawings and engravings was pro-longed and at times ill-tempered. Blundell did not want to spend too much money on the project and refused to have a "foreigner" in his house to do the drawings. Drawings had to be done locally and then sent to London for engraving. Artists in London called Skelton and Howard are mentioned in the cor-respondence[27]. A considerable number of the descriptions were dictated by Blundell whilst con-fined to bed through illness, being now in his eighties and losing his sight, and a local schoolmaster who took the dictation may have contributed to the con-tent as well. Blundell's comment in the introduction of the work is worth noting . . . "Pains have been taken to make the descriptions short and to avoid all pagan allusions and mystical erudition". He then quotes the dictionary definition of 'mystical' – "inac-cessible to the understanding – artfully made diffi-cult".

The Account and the Engravings often contain a wealth of information about individual pieces and their history which compensate partially for the com-plete lack of archive or documentary evidence. A male statue (Ince no.569) (*Figure 9*), described as "Marcus Aurelius", "was met with in a sculptor's yard in London but how it came, or from whence, could not be discovered. It is supposed to have been sent over from some palace at Rome upon specu-lation"[28].

A statue of Apollo Sauroktonos (Ince no.558) (*Figure 10*) "was found by Mr. Gavin Hamilton, in one of

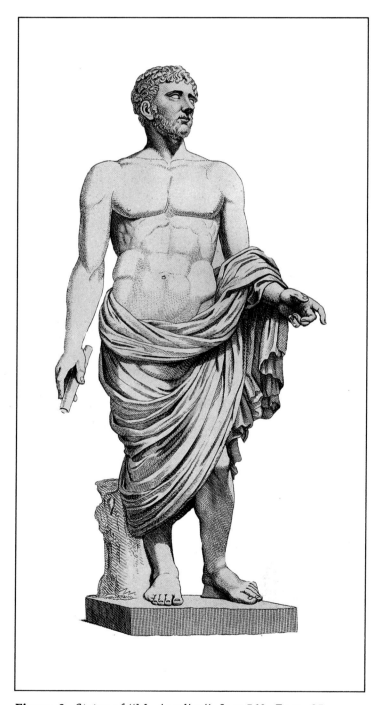

Figure 9. *Statue of "M. Aurelius". Ince 569. Engr. 35.*

27. There is a long sequence of letters on this topic from Henry Blundell to Charles Townley from 1798–1802 as well as lists of plates and copies of delivery notes from Skelton. Some of the pieces bought by Townley for Blundell in London were drawn before delivery to Ince by Nollekens. Blundell was worried that the costs of the enterprise kept escalating and wanted to monitor the work more closely. At the same time he kept on changing his mind about which pieces were to be included and was hardly co-operative about getting drawings done. Townley was exasperated at Blundell's implied suspicions about costs, particularly when he had difficulty cashing Blundell's bank drafts in London. The style of Blundell's letters could hardly be considered tactful and Townley took offence on several occasions.

28. Blundell Eng. pl.35. This piece is not in the Account, implying that it was purchased after May 1802.
 It is just conceivable that the sculptor in question was Thomas Banks. Ince no.554 came from Banks after his death and Blundell did number his groups in sequence. The piece is a patchwork of restorations of indifferent quality, suggesting that it was assembled in England rather than in Rome. However, Joseph Nollekens was also a supplier of "botched antiques", dextrously restoring heads and limbs and staining the result with tobacco water. See John Thomas Smith, *Nollekens and his times*, London (1986) p.10, (first published London 1828).

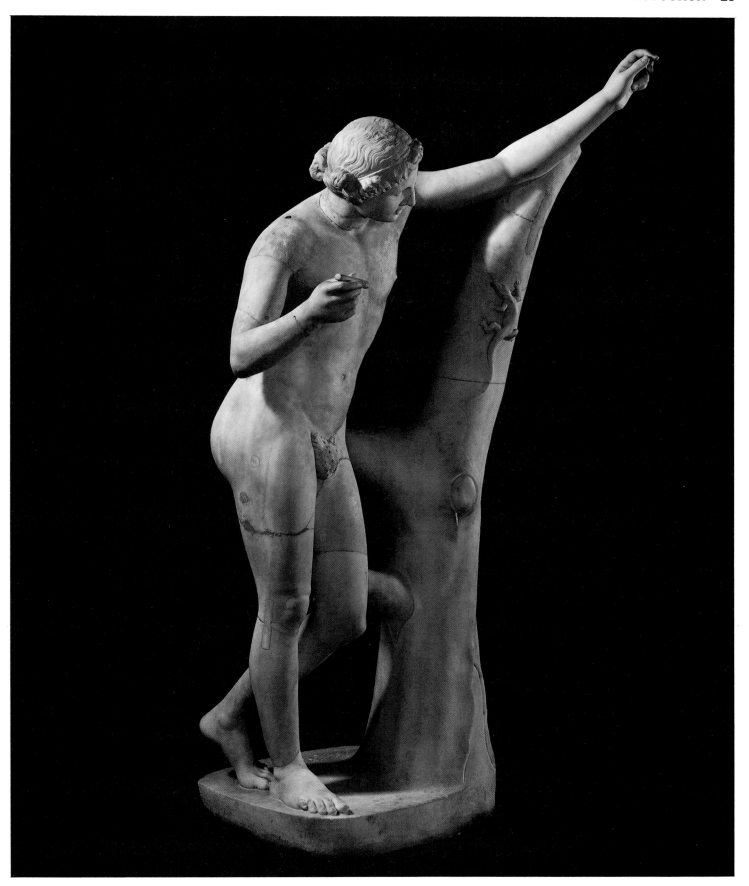

Figure 10. *Statue of Apollo Sauroktonos. Ince 558.*

his cavas near Rome, and is said to be in better preservation than any of the others. It was purchased and brought over to England, for Mr. Robert Heath-cote, at great expense. In the Royal Academy at London, is a cast of it, taken by the late Mr. Banks, sculptor"[29]. One of the most colourful comments comes on a sleeping hermaphrodite (Ince no.531) (*Figure 11*). "Bought at Roehampton, at a sale of Lord Besborough's, by a friend with a deal of erudition about it. When bought, it was in the character of a Hermaphrodite, with 3 little brats crawling about its breast. The figure was unnatural and very disgusting to the sight; but by means of a little castration and cutting away the little brats, it became a sleeping Venus and as pleasing a figure as any in this Collec-tion"[30]. A drawing of this piece before the "cas-tration" exists in the Townley collection in the British museum (*Figure 12*)[31].

29. Blundell Eng. pl.36. Again this piece is not in the Account. The reference to Banks and its number in the sequence might imply the same source as no 569.
30. Blundell Eng. pl.41. Blundell Acc. pp.182–3 refers to it in its unaltered state, implying that the alteration had not been done by 1802/3 and was done later while at Ince.
31. My thanks are due to Ian Jenkin of the British Museum for bringing this drawing to my attention.

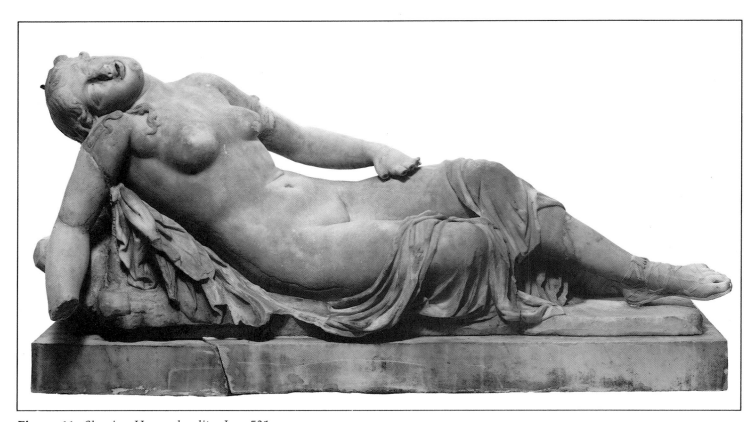

Figure 11. *Sleeping Hermaphrodite. Ince 531.*

The Collection after Henry Blundell

Henry Blundell died on 28th August 1810, shortly after the completion of the Engravings and the Pantheon. The Garden Temple seems to have been a dumping ground for those pieces not wanted in the Pantheon and his son Charles appears to have done little with the collection. Charles had never married, to the anger of his father and there appears to have been much friction between them[32]. This was exacerbated by very generous legacies from Henry to his two daughters. When Charles died in 1837 at the age of 76 he left the collection and estate to a relative by his grandmother, Thomas Weld of Lulworth in Dorset, on condition that he took the name of Blundell. Not surprisingly Henry Blundell's two daughters, now Lady Camoys and Mrs. Tempest, objected to this apparently spiteful arrangement and the will was contested, helped by a drafting error. After a lawsuit which lasted ten years and an appeal as far as the House of Lords, the will was allowed to stand and the estate duly passed to Thomas Weld Blundell. It is unclear what happened to the estate and the collection during the lawsuit and it appears to have suffered some neglect. Tradition has it that the family archive was destroyed, removed or allowed to deteriorate at this time. Certainly it did not survive into the second half of the century.

Thomas Weld Blundell was sympathetic to the collection, though he devoted his principal energies to restoring the estates, extending the Hall, and planting trees to protect his land against encroaching sand-dunes. By 1870 "the Hall which was for many years in a state of great dilapidation, has recently been restored with a degree of elegance and taste which does credit to its possessor"[33]. Adolf Michaelis, visiting in 1873 and 1877 comments on the "exceeding liberality" of Mr. Thomas Weld Blundell who not only allowed undisturbed study, but also photography and the making of casts. Michaelis listed the collection in considerable depth and included the

32. Various letters from Henry Blundell to Charles Townley mention his son, e.g. 10th February 1799, "The rambling life he has led for many years, living mostly at inns, . . . His chief employ here is reading the newspapers and magazines, walking, visiting his horses, and going out now and then with his gun. Had he a wife and family, his time wd be better filled up and he might become a different character in life."

33. Baines, *History of the County Palatine and Duchy of Lancaster*, Vol.II (1870) p.396.

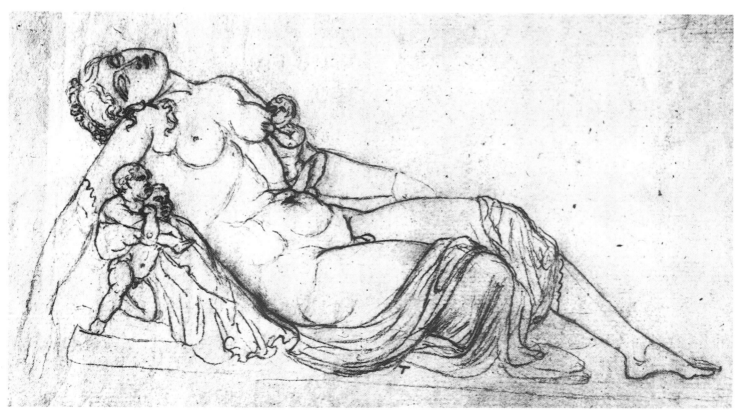

Figure 12. *Sleeping Hermaphrodite. Drawing in the Townley Collection. Reproduced by courtesy of the Trustees of the British Museum.*

details of provenance taken from the Account and the Engravings. Sad to say, he was unable to trace all the pieces from the collection. The Pantheon he describes as in "tolerably motley confusion", but the Garden Temple is described as "this very dilapidated building . . . a lumber room . . ., where the stores are crowded together and piled one on another"[34].

Charles Joseph Weld Blundell succeeded Thomas in 1887. The collection started the twentieth century little changed from several decades before. In 1919, when the Danish scholar Frederik Poulsen revisited Ince, the Garden Temple was "even now a chaos of statues, busts, beams, plinths, packing cases with decayed straw, and casts of the Elgin Marbles, a regular Sleeping Beauty idyll which has not yet found its prince"[35]. Poulsen seems to have had a particular affection for Ince. "I first began to be interested in English private collections in 1912 when I was sent by Carl Jacobsen to Ince Blundell Hall, with an Italian from Liverpool, to procure casts of the head and arms of the famous Ince Athena, of which the Ny Carlsberg sculpture gallery possessed a replica without head or arms. Thanks to Mr. Weld Blundell's courtesy we were well received, and while the work was progressing, I had time to look around the collection of antiquities in the house and the little temple in the Garden, and saw how much material was there, hitherto unknown, for the history of ancient art"[36]. Poulsen was the first scholar to illustrate a large portion of the collection in a publication, using photographs taken in 1919. It was a difficult time for the Weld Blundell family who had lost two sons during the war years. The estate and house were neglected and Poulsen was not initially encouraged in his task.

The trough of depression which had hit the family appears to have lifted within a few years. Bernard Ashmole started work in 1922 on an illustrated catalogue of the collection[37]. By then the collection had been restored to good order and renumbered by the family. Ashmole comments on the "admirable re-arrangement". The aim of the 1929 publication was simple – to illustrate all the ancient marbles and some of the more interesting fakes and forgeries. He took his own photographs where the pieces were access-ible. What the photographs did not show he described, including their condition, dimensions and restorations. As he says in his introduction, this makes the material "available to scholars and pro-vides, not a substitute for autopsy – there is none – but as a means of judging what objects are worth further study"[38]. Some evidence of the previously

chequered history of the collection can be seen by the fact that Ashmole only numbered some 413 items. Of these many are dismissed because Ashmole con-sidered them adequately described by Michaelis. Many of the urns and inscribed pieces fall into this category. Others are considered unimportant or modern and therefore merely listed. In addition there were some he could not find, as indeed neither could Poulsen or Michaelis. Not all were accessible. Some of the pieces built into the top frieze round the Pan-theon are barely visible from the ground and photo-graphy of these was out of the question in 1922.

The Gift to the City

Ashmole's 1929 publication has been the standard work on the collection, bringing it through the illus-trations to the attention of scholars in a way that Michaelis could not. After 1929 the collection became more familiar to the academic community and pieces began to appear in articles and books in greater num-bers. The Weld Blundell family continued the tradi-tion of public access originally set by Henry Blundell. Though it remained a private house, the grounds, Temple and Pantheon were opened on a regular basis and postcards and a guide were on sale by the 1950s.

Charles Weld Blundell had lost his only two sons during the war years and the estates passed to his two daughters in 1922 for their lifetimes. One died in 1947 and the other in 1958. The hall and estates therefore passed to Colonel Joseph Weld of Lulworth in Dorset who was the next in line though not a direct descendant. Colonel Weld decided that he was unable to keep Ince as a second home and the Hall, estate and collection were offered to the National Trust. Agreement could not be reached, however, and he decided to sell the Hall and estates. The collec-tion of sculpture was offered as an unconditional

34. Michaelis p.335. Michaelis was the first scholar to include photographs of the collection in a publication. Michaelis, *Priv.* has five plates and a copy of an engraving to illustrate an article on English private collections.
35. Poulsen p.18.
36. Frederik Poulsen, *Foraar i Spanien. Sommer i England* (1950). This is part of Poulsen's autobiography. For a translation of the section referring to Ince, see J. Fejfer and E. Southworth "Summer in England – Ince Blundell Hall Revisited", *Apollo Magazine* (March 1989) pp.179–182.
37. Ashmole.
38. Ashmole p.vii.

gift to the City of Liverpool[39]. The generous gift, however, was not without considerable difficulties. In 1941 an incendiary bomb had fallen on Liverpool Museum at the height of the blitz on that city and the museum was burnt to the ground. Many thousands of specimens were destroyed, though much survived in store in an isolated part of Wales. After the war the City had higher priorities than the rebuilding of the museum, with new housing and industry taking the bulk of the post-war reconstruction effort. By 1959 some of the less badly damaged galleries had been re-occupied on a temporary basis but the main museum building was still in ruins, the staff and collections being housed in an old hall across the city. If the collection was to be accepted, there was no chance of displaying it immediately. Suggestions for its use ranged from erecting a new building in one of the city parks to dispersing it throughout the city's schools as an aid to teaching the classics. Colonel Weld was aware of the fact that his gift might be an embarrassment and in his initial letter to the Liverpool Town Clerk suggested that he hoped to make arrangements with the new owners to allow the city to use the Garden Temple for displaying the collection to the public for the next five years. In the event this option was not possible, but the City Council were convinced of the need to keep the collection as complete as possible and avoid dispersal.

The actual gift was stated to include all the movable pieces of ancient sculpture, and any of the embedded reliefs that the Museum wanted. All the pictures, bronzes, modern marbles and books in the house were to remain with the family. An immediate difficulty was therefore to decide which of the embedded reliefs should be removed. A letter from the Director to Bernard Ashmole asking his advice on the matter talks of his own secret hope that the collection might return to Ince at some time in the future[40]. There was a natural reluctance to mutilate the Pantheon and the Temple by removing the reliefs and other sculptures which so obviously had influenced the actual design and construction of the buildings themselves. In the event the gift of the collection was gratefully accepted by the City Council on 19th December 1959 on behalf of the museum, but the questions about the future use and location of the collection as well as exactly what it comprised were left unanswered.

Ince Blundell Hall was sold at a very favourable price to a nursing order of nuns for use as a convalescent home. Within weeks the solicitors for the new owners were making it clear that the Pantheon was wanted for use as a chapel and that all the reliefs still fixed to the walls would have to be removed within six months[41]. They later confirmed that if the museum did not remove the sculpture, it would not even be accessible to scholars in the future. This meant abandoning any immediate plans to reunite the collection with the building. Over the next six months the museum paid a local sculptor to remove the reliefs embedded in the walls of the Hall and the interior of the Pantheon and then to reinstate the ornamental plasterwork. The Garden Temple proved more of a problem. The idea of leaving a group of the movable sculpture in situ in the Garden Temple had been abandoned when restrictive conditions on the number and supervision of groups had been imposed by the new owners. Removal of the pieces embedded in the walls of the Temple was eventually abandoned after a report from the City Engineer stated that there was considerable risk of destroying the Temple in the process. "It is obvious from the badly fractured plasterwork encasing the roof timbers and the cornices, that the roof construction is in a defective or possible dangerous condition. Furthermore the wall plastering is generally in a very poor condition"[42]. At the close of the removal operation, therefore, a substantial group of pieces remained at Ince. These included all the reliefs on the exteriors of the Pantheon and Temple as well as all those in the interior of the Temple. Several other pieces also remained, such as the Amazonomachy relief (Ince no.333) built into the dairy and a major sarcophagus with a marriage scene (Ince no.341) in a summerhouse attached to the greenhouses. This last piece was judged to be at considerable risk by 1986 and was removed from the now derelict summerhouse by the Liverpool Museum conservation team. It is currently on loan to the museum pending restoration and a decision about its future location.

39. Information in conversation with Sir Joseph Weld 1988. Formal offer in letter from Col. J.W. Weld to Liverpool Town Clerk 3rd December 1959.

 The information in this and succeeding paragraphs has been extracted from an inevitably large file of correspondence and other documents relating to the gift in 1959–61. This is now held in Liverpool Museum, Accession number 1959.148. References have only been made to the most important documents.

40. Letter from T. Hume (Liverpool Museum Director) to Bernard Ashmole 12th December 1959.

41. Letter from E.T. Furlong (Solicitor) to Mr. E. Weld (Solicitor) 15th January 1960.

 It should be pointed out that the nuns have allowed scholars access to the material at Ince for many years now.

42. Letter from H.T. Hough (Liverpool City Engineer) to Liverpool Town Clerk 29th April 1960.

In the event, the bulk of the modern pieces came with the collection, destined for display in the Walker Art Gallery, with only a few pieces remaining in private hands, including many of the bronzes listed in the Blundell Account.

Recent History of the Collection

Throughout the 1960s the ancient part of the collection remained in store simply because there was nowhere to display it. In 1966 the main building of the museum reopened but it was not until 1973 that work started on a new gallery for the Humanities, to display material from the ancient Mediterranean world. Opened in 1976, the display features 45 of the finer pieces from Ince in a circular setting intended to recreate the atmosphere of the Pantheon at Ince.

In 1979 work commenced on moving the remainder of the collection from the unsuitable storage conditions it had been in since 1960. It is now all in the main museum store where a programme of cleaning has been carried out. It was then possible to begin photographic and documentation work to enhance the existing museum records. The use of computers in museums has developed rapidly in recent years and the collection documentation has been transferred to this medium.

In December 1988 a new gallery dedicated to European sculpture of the 18th and 19th centuries was opened at the Walker Art Gallery. This features some 40 pieces from the Ince collection and includes most of the "modern" work by Albacini, Cavaceppi, Piranesi etc.

The Current Position at Ince

The Hall at Ince Blundell is still used as a private convalescent home for the elderly. The grounds and main building are well maintained and an air of tranquillity exists, as befits the function of the estate. Its use for this purpose has meant, however, that the owners have been deprived of many sources of public support for the fabric of the buildings as such support is often conditional upon public access. Whilst the Hall itself, which is used on a continuous basis, is well maintained and has had considerable sums of money spent on it, the structures erected by Henry Blundell for his collection have been less fortunate.

The Pantheon appears to be structurally sound as it shares the heating system of the Hall and is therefore protected from extremes of climate. The Garden Temple, however, has suffered from the neglect noticed by Michaelis, Poulsen and the Liverpool City Engineer. It was originally linked by a corridor to the greenhouses of the Hall garden and connected to their heating system. This had been out of commission for many years and the greenhouses have been systematically removed over the past decade as unsafe. The Temple has thus had little protection against damp and became riddled with rot. Whilst it is a brick structure, the internal plaster moulding was on a wooden framework. By 1980 the timber had decayed beyond repair and the actual structure of the walls was becoming threatened by the damp. External assistance with funding was made available to the owners and the local planning authority responsible for the statutory protection of historic buildings organised the repair of the building. This process took place under the auspices of Sefton Borough Council rather than the Liverpool Museum as the Museum has no statutory involvement in this field. Repair work to the building proved to be a major task and had a drastic effect. All the plasterwork and its timber framework was removed to get access to the brickwork. Where this was repaired, concrete blocks were used to support arches and niches. A completely new roof was installed and the entire building made structurally sound. The process of removing the plaster moulding meant that the sculpture still embedded in the walls had to be removed. After a spell in storage this is now kept in the Temple, which is still unheated. At the time of writing there has been no reinstatement of the plaster moulding or any interior decoration. In any case there was so little of the original preserved that a completely new interior would be needed.

The Physical Condition and Conservation of Marble Sculpture

The physical condition of the collection bears a direct relationship to the history of the individual pieces. The bulk of the pieces came through the art market in Rome in the last quarter of the 18th century. Dealers in this market employed restorers and sculptors to adapt the raw antiquities to the English taste[43]. Many of these, such as Antonio D'este, Cava-

43. For a discussion of the English collectors and their requirements see Dirk Kocks, "Antikenaufstellung und Antikenergänzung im 18. Jahrhundert in England", in Antikensammlungen im 18. Jahrhundert. This topic will be covered in more detail in G. Vaughan (forthcoming in this series).

ceppi, Piranesi and Albacini have now gained reputations as artists in their own right. Their major works are usually identifiable, but minor repairs are often very difficult to attribute exactly. As the collection was entirely formed within a comparatively short period of time, it represents a valuable insight into the methods and techniques of the restorers of the period. Accordingly the repairs and additions are seen as important evidence for the history of the object and are kept on the object wherever possible.

As the great majority of pieces were restored in the 18th century, they all tend to suffer from the same problems to varying degrees[44]. Iron pins have been widely used to strengthen joints or attach new pieces of stone. These pins are embedded in lead or in organic adhesives such as shellac. Staining from the iron can migrate through the stone to the surface causing an unpleasant brown appearance, but the oxidation of the metal can also cause structural damage, acting as a wedge which splits the stone. This process has been exacerbated by the damp condition in which much of the sculpture has been kept over the years.

A smaller number of sculptures have suffered from surface weathering and decomposition due primarily to exposure to the elements. This is particularly obvious on pieces such as a seated statuette of a woman as Fortuna (cat. no.6, Ince 54 in this volume) which was placed in an outside niche of the Pantheon building at Ince. If the atmosphere surrounding the sculpture is contaminated by various pollutants, however, the surface deterioration can be more severe. The presence of sulphur in the air can cause both breakdown of the calcite and the formation of calcium sulphate deposits. Sulphur compounds are found as a result of the domestic use of fossil fuels such as the coal fired heating system used at Ince, but are now increasingly recognised as a more general pollutant causing the phenomenon known today as "acid rain" or more correctly "acid deposition"[45]. Marble which has been attacked in this way often disintegrates of its own accord and the phenomenon is known as "sugaring" after the feel and appearance of the stone.

44. For a brief, but exemplary, discussion of the conservation of ancient sculpture see David Rinne, *The Conservation of Ancient Sculpture*, The J. Paul Getty Museum (1976). Our experience of the conservation of the Ince material confirms his observations.
45. Evidence for the serious air pollution suffered even in the countryside at Ince can be found in Ashmole p.59 referring in 1922 to Ince 578 which is on the external frieze of the Pantheon; "one cannot be certain of these (restorations) owing to corrosion by soot, which also forbids casting". The "soot" is in fact a deposit of calcium sulphate. Only in recent decades has the quality of the air improved sufficiently in the environs of the city to halt this process.

THE ROMAN FEMALE PORTRAITS

CATALOGUE

Note on Arrangement

The importance of the collection and of the portraits as a group lies in the context of their acquisition, restoration and display in the 18th century. Therefore, and for identification purposes, the total height including the 18th-century restoration is given.
One of the views in the plates will always show the complete object.

It has been found that particular attention should be paid to the description of the restoration and surface condition of the individual pieces because the long and varied history of the collection is reflected in such details. The second part of this volume, on the Roman male portraits, will include a discussion on Roman portraits from the Ince Blundell Collection in the 18th-century context of collection, restoration, and display.

When two alien pieces have been restored together, only the portrait is discussed in detail. Further volumes will include male portraits/statues.

The figures within the notes to each catalogue entry are taken from Blundell's Engravings. The accompanying texts are transcribed from Blundell's Account.

Catalogue 1

Ince no.35. Miniature portrait of a woman restored on an ancient statuette.

Total height: 0.588m.; height of head: 0.09m.; height from chin to hair-line: 0.066m.; height of ancient part of body: 0.38m.

Marble: head: grey, medium-crystalled;
body: white, fine-crystalled.

Restored, head: nose and neck. Surface: porous and probably exposed to fire. Some reworking.

Restored, body: both arms with attributes, and lower part of legs with plinth.

Lit.: Blundell Acc. 35; Michaelis, *Priv.* p.26 no.71; Michaelis p.35 no.71; Ashmole p.32 no.71.

Provenance unknown.
Displayed at Ince in the Pantheon.

The head is alien to the body and has probably been exposed to fire. It shows a woman with a typical Republican "Nodus" hairstyle. The hair on the crown of the head is separated into two strands of hair which each form a nodus in the forehead. On the top of the head the strands unite into one tight plait. The hair on the sides of the head is combed behind the ears and then made into a little tight plait on either side of the head. All three plaits are then gathered into a round low-placed knot at the nape of the neck.

The nodus hairstyle came into fashion from around 40 B.C. and lasted into the early first century A.D. with only minor changes[1]. The plait on the top of the head, the rather loose arrangement of the hair on the sides of the head[2], and the bipartite nodus[3], probably date the Ince head to the early to mid Augustan period,(i.e. B.C. c.30–10).

The miniature scale of the portrait suggests that it may have been intended for display in a private domestic (portable?) context[4].

Of the statuette the torso seems basically ancient.

Notes:

In Blundell's Account: *35. Hygeia.*
This small figure, called Hygeia, daughter of Aesculapius, holds in one hand a patera, and in the other a serpent, as she is often seen. Few personages have been so often repeated in sculpture as Aesculapius and his daughter. In remote times they were so famous for their skill in medicine, and were said to have restored so many to health, and even some to life, that they were deified for it, and were held in great veneration.

1. See D.E.E. Kleiner, *Roman Group Portraiture. The Funerary Reliefs of the Late Republic and Early Empire.* Fine Arts Diss. New York (1977) p.131 ff, and K. Polaschek, "Studien zu einem Frauenkopf im Landesmuseum Trier und zur weiblichen Haartracht der iulisch-claudischen Zeit", in *Trier Zeitschrift für Geschichte und Kunst* 35 (1972) p.151 ff.
2. See Kleiner, *op. cit.* note 1, pp.135–136.
3. *Ibid.* p.225 cat. no.51 and pl.51.
4. Emperor portraits of small scale have been treated by R. Schneider, *Studien zu den kleinformatigen Kaiserpörtrats von den Anfangen der Kaiserzeit bis ins dritte Jahrhundert.* Diss. Munich (1976), whereas there is no thorough examination of private portraits of small scale and their use.
 For display in private houses, see E.J. Dwyer, *Pompeian domestic Sculpture.* Rome (1982) pp.127–128.
 There is much useful information for the early period in G. Lahusen, "Zur Funktion und Rezeption des römischen Ahnenbildes", in *RM* 92 (1985) p.261 ff.
 See also N. Hannestad, "Thorvaldsen's Small Silver Head – A ruined Tondo Portrait", in *Meddelelser fra Thorvaldsens Museum* (1982), especially p.59.

Catalogue 2

Ince no.120. Portrait of a woman restored on a modern bust.

Total height: 0.535m.; height of ancient part: 0.26m.; height from chin to hair-line: 0.145m.

Marble: white, fine-crystalled, probably Italian.

Restored: rim (missing) and lobe of left ear, rim of right ear (missing), top of hair, lower part of neck with bust, and base with index-plaque. Surface: hair weathered and some details almost lost. Face entirely worked over in modern times.

Lit.: Blundell Acc. 120 and Blundell Eng. 59,1 and 66,1; Michaelis, *Priv.* p.27 no.104; Michaelis p.361 no.104; Bernoulli II 2 p.41; West II p.32; Poulsen p.64 no.45; Ashmole p.46 no.104; U. Hausmann, "Bildnisse zweier jünger Römerinnen in Fiesole", in *Jdl* 74 (1959) p.175 n.40; Wegner, *Herrscherbild Die Flavier* p.115.

Provenance unknown.
Displayed at Ince in the Pantheon.

The head is about life-size and turned to the left. The front hair is combed forwards from a parting running across the crown of the head. It is arranged in a high diadem-like toupee which encircles the face and almost covers the earlobes. The toupee consists of several small snail curls of different size. In the centre of each curl is a deeply drilled, clearly defined hole, and drilled holes also occasionally appear between the curls. The rest of the hair on the crown is combed straight backwards. Together with the loosely twisted strands of hair at the neck it is made into several thin

plaits which are gathered into a large ring-shaped bun placed high on the head. A small wispy curl falls down the neck behind each ear (now nearly invisible).

Apart from the hairstyle hardly any features characterize the head as a portrait. In particular, the modelling of the eyebrows and the lower parts of the face seems more in the conception of 18th-century A.D. sculpture than ancient portraiture[1].

Attempts by Bernoulli and West to identify the head as a portrait of Julia Titi have been rejected by later scholars[2]. Clearly the portrait does not derive from any of the known portrait types of Julia Titi[3]. Furthermore there seems to be a substantial discrepancy in time between Julia Titi's portraits (A.D. c.80–90)[4] and this portrait. Julia Titi's hairstyle is characterised by a thick sponge-like toupee, a relatively small and low placed chignon, and several thin plaits covering the whole back part of the head. On the Ince toupee the typical Flavian sponge-like appearance has been replaced by a rather stereotyped drill work in a manner close to that which is seen, for example, on the allegorical figures on the reliefs of the arch of Trajan at Benevento from A.D. 114[5]. The ring-shaped bun is also typically Trajanic[6], and the Ince portrait must be dated to the middle to the late Trajanic period (i.e. A.D. c.110)[7].

It is often difficult to determine to what extent artificially added hair was used to create the often very elaborate hairstyles of the Roman female portraits[8]. Marble toupees[9], and whole marble wigs[10], as well as a reference in ancient literature[11] clearly show that artificially added hair was used. Two Hadrianic stucco reliefs from a grave near Carthage illustrate the build-up of a hairstyle identical to that of the Ince portrait[12]. In scene B of the reliefs ("Reading scene") a woman is shown wearing a hairstyle like the one seen on the Ince head. In scene A ("Toilette scene") the same woman is having her hair done by a slave. The toupee is already in place while the bun is being made from very long and clearly natural hair.

Notes:

In Henry Blundell's Account: *120. Julia.*
The head-dress of this bust is singular, as in most of this empress. She was the daughter of Julius Caesar, famous for her personal charms and virtues. She married Pompey the Great, and for some years cemented the friendship of those two men.

Blundell may only have been informed that he had bought a portrait of Julia, and the identification of the portrait as Caesar's daughter probably pleased him, although it is clear from the hairstyle that the Julia in question was Julia Titi.

***Figure 13.** Portrait of a woman restored as a bust. Cat. no.2. Ince 120. Engr. 59,1; 66,1.*

1. It is possible that some of the sculptures without provenance in the Account were collected and restored in England, see G. Vaughan (forthcoming in this series). There is also proof that Blundell had pieces altered once at Ince, see Introduction note 30.
2. So Michaelis (Vespasianic), Poulsen (Domitianic), Ashmole (Domitianic), and Hausmann in *JdI* 1959 (Domitianic), and Hausmann in *Herrscherbild Die Flavier* (late Domitianic).
3. See Wegner, *Herrscherbild Die Flavier*, p.115, U. Hausmann, "Zu den Bildnissen der Domitia Longina und der Julia Titi", in *RM* 82 (1975) p.315 ff., and I. Rilliet-Maillard, *Les portraits romaines du Musee d'art et d'histoire Geneve*. Geneve (1978) p. 37ff. no.11.
4. *Ibid.*
5. See M.Rotili, *L'arco Traiano a Benevento*. Rome (1972) pl.28. and 31.
6. See for example Fittschen/Zanker *III* no.77.
7. A grave relief with a married couple in the Museo Capitolino depicts the man with a typical Trajanic hairstyle while the woman wears a toupee hairstyle similar to the Ince portrait, see Stuart Jones no.65 pl.23. See also a grave altar in the Vatican Museums, inv. 1038 in D.E.E. Kleiner, *Roman imperial funerary altars with portraits*. Rome (1987) p.170 no.49 pl.31.
 For an absolutely dated provincial representation of an identical hairstyle, see note 12.
8. See P. Erhart Mottahedeh's review of Fittschen/Zanker *III* in *AJA* 90 (1986) p.134.
9. Ostia Museum, see Calza. *Ostia. I Ritratti* I, p.109 nos. 191–192.
10. See K. Schauenburg, "Perückträgerin in Blattkelch", in *Städel Jahrbuch* 1 (1967) p.57 figs. 19–21.
11. Tertullian, *De Cultu Feminarum*, 7.
12. From stamps on tiles dated to the reign of Hadrian (A.D. 117–138), see *De Carthage a Kairouan. 2000 ans d'art et d'histoire en Tunisie. Exhibitions du Musee du Petit Palais de la Ville de Paris 20/10/1982–27/2/1983.* Paris (1982) p.138 no.194 with ill. and previous references.

Catalogue 3

Ince no.226. Portrait of an old woman restored as a double herm with male portrait.

Total height: 0.5m.; height of ancient part: 0.23m.; height from chin to hair-line: 0.169m.

Marble: white, fine-crystalled, probably Italian.

Restored: back part of head with hair above temples, both ears and part of right cheek, nose, bust, and base. Damage to top of hair and face. Surface: porous with pitting marks and a light yellowish patina. Cleaned by chemicals.

Lit.: Blundell Acc. 226 and Blundell Eng. 62,2; Michaelis, *Priv.* p. 27 no.112; Michaelis p.362 no.112; Poulsen p.70 no.52; Ashmole p.49 no.112; Howard pp.79–80.

Purchased from Bartolomeo Cavaceppi.
Displayed at Ince in the Garden Temple.

The portrait depicts an old woman with a wrinkled face. A wig-like toupee encircling the forehead is divided into two parallel bands each vertically separated into several feather-like strands of hair. The hair on the crown of the head is combed straight backwards. By the left temple, at eye level, is a little curl. The eyes, of which the left is placed a little higher than the right, are long and narrow without any indication of iris or pupil. The tight mouth with sagging lips seems toothless and the left corner of the mouth is lower than the right one. This asymmetry is underlined by the different length and depth of the furrows on either side of mouth and nose. Details of hair are indicated by incision rather than modelling.

Several portraits of the Trajanic period show a similar feather-like toupee arrangement except that the toupee more frequently consists of a single band of feathering while a narrow band of hair (the so-called ''Sockelelement'') covers the transition from forehead to front hair[1]. A portrait on a grave altar of one Statilius Aper, dated to the late Trajanic or early Hadrianic period (i.e. A.D. 110–120)[2], shows a hairstyle very close to the Ince portrait, suggesting a likely date in the later Trajanic period[3].

The portrait belongs to a group of portraits of old women appearing in the Flavian/Trajanic period (i.e. A.D. c.70–110)[4]. These portraits are often of dry, somewhat inferior quality[5] and seem closely related to the contemporary portraits seen on grave reliefs of freedmen[6]. They probably therefore depict women of that social group, and many of them may have served as tomb portraits too. The somewhat summary dry workmanship strongly suggests that the Ince portrait was originally part of a tomb monument, either a bust[7], or a statue, or possibly even part of a relief[8] which would explain the missing back part of the head[9].

Poulsen, Ashmole and Howard have pointed out previously that there is no evidence for the two portraits of the double herm having originally belonged together. The male portrait seems much earlier and the remarkable restoration into a double herm must be the idea of Cavaceppi[10]. A characteristic detail found in other portraits restored in Cavaceppi's Studio is the flame-like appearance of the tufts on the crown of the double-herm[11].

Notes:

In Blundell's Account: *226. A Bifrons.*
It is difficult to ascertain the meaning of many of these double faces. This is supposed to represent a man and his wife. Their characters seem strongly expressed. It was bought from Cavaceppi.

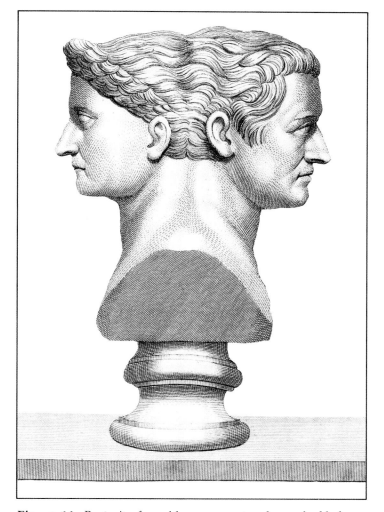

Figure 14. *Portrait of an old woman restored as a double herm with a male portrait. Cat. no.3. Ince 226. Engr. 62,2.*

1. For the official portraits, see Wegner, *Herrscherbild. Hadrian*, p.77 ff. and pl.35 for Marciana, and pl.37 for Matidia.

2. For the Statilius Aper grave altar in the Museo Capitolino, see West II p.25 no.92, and also P. Zanker, "Ein hoher Offizier Trajans", in Eikones, Festschrift Hans Jucker, *Antike Kunst, Beiheft* 12 (1980), p.200 and pl.67,4, and latest D.E.E. Kleiner, *Roman Imperial funerary altars with portraits*. Rome (1987) p.213 no.83 pl.46.

3. A hairstyle with two horizontal bands of hair is seen on the personifications on the reliefs of the triumphal arch of Trajan in Benevento, see M. Rotili, *L'arco di Traiano a Benevento*. Rome (1972) pl.32.

 A portrait formerly in Palais Lanckoronski shows a feathering hairstyle close to the Ince portrait, see DAI Inst. Neg. 1530.
 For a list of portraits with two band hairstyle, see Fittschen/Zanker III p.52 no.67 note 1.

4. For the reappearance of portraits revealing old age in this period, see in *Geschichter*, p.131 no.53.

5. See in Fittschen/Zanker III p.52 no.67.

6. For grave reliefs of freedmen, see P. Zanker, "Grabreliefs römischer Freigelassender", in *JdI* 90 (1975) p.267 ff.

7. For a bust of a woman of the Roman middle class? in a possible grave context, see Fittschen, *Erbach* p.79.

8. Also Howard, see Howard p.82.

9. Grave reliefs could be cut in very high relief so that details even on the back of a toupee were executed, see for example H.Wrede, "Das Mausoleum der Claudia Semne", in *RM* 78 (1971) p. 126 ff. and pl.79.

10. For the limited use of herms/double herms for portraits of the Roman period, see H. Wrede, *Die antike Herme*. Mainz (1986) p. 71 ff. There are other examples of double herm/statuette restorations from Cavaceppi's Studio, see the Inventory Monumenti in Howard p.387 no.483, p.391 no.797, p.392 no.814, and Ince 139.

11. See Ashmole nos. 154, 196, and 201.

Catalogue 4

Ince no.132. Fragmentary portrait of Empress Faustina Maior restored on a modern bust.

Total height: 0.545m.; height of ancient part: 0.223m.; height from chin to hair-line (measure based on restoration): 0.16m.

Marble: white, fine-crystalled, probably Italian.

Restored: patch on left eyebrow, both ears, lower part of face with bust, and base with index-plaque. Surface: hair porous and probably cleaned with chemicals. The hard rendering of details around the eyes and the "ridge" around the hairline show that the face is deeply cleaned and partly worked over.

Lit.: Blundell Acc. 132 and Blundell Eng. 61, 1; Michaelis, *Priv.* p. 27 no. 109; Michaelis p.361 no.109; Bernoulli II 2 p.155 no.24; Ashmole p.48 no.109; Wegner, *Herrscherbild Ant. Zeit* p.156; Fittschen, *Erbach* p.81 no.4; Wegner, *Vz. I* p.128; Howard fig. 207[1]; Fittschen/Zanker III p.15 no.13 note 6.

Provenance unknown.

Displayed at Ince in the Greenhouse.

The person depicted in this just over life-size portrait is the empress Faustina Maior. The hairstyle is arranged in crimped waves which follow the oval head contour closely and a large bun is placed on the crown of the head. In spite of the drastic cleaning, incision for eyebrows and iris, and drilling for pupils is still traceable and shows that the gaze was directed to the right. The drilling of the lachrymal canal, however, seems modern.

Faustina Maior is known from portraits on coins, several portraits in the round, and on relief sculpture. The Ince Faustina Maior derives from the so-called "Museo Capitolino, Imperatori 36" type[2] which is the most frequently copied of the three Faustina Maior portrait types[3], known in 24 replicas[4]. The replicas show only few minor deviations, mainly concerning details of hair[5]: a parting behind the left ear and a twisted strand of hair on the right side of the head are seen on a number of the replicas as also on the Ince portrait[6]; however, a twisted strand of hair which runs parallel to the bun on the left side of the head on four of the replicas[7] is missing on the Ince replica. The four replicas with this twisted strand of hair on the left side of the head are the four replicas which Fittschen suggests come closest to the prototype[8].

The rough cleaning makes an exact dating of the portrait based on stylistic analysis difficult. In the hair however, it is notable that the crimped waves and the individual strands of hair are modelled into a natural softened effect between light and shadow. If Fittschen is right in assuming that a linear execution of the hair belongs to the posthumous examples of this type[9] (i.e. after A.D. 141), the Ince portrait seems to date among the earlier portraits, but not necessarily made during her lifetime. Faustina Maior lived only three years into Antoninus Pius' 23 year long reign and they were founders of a new dynasty which needed consolidation for the future[10]. On these grounds alone one might expect to find many posthumous statues erected in her honour. This is confirmed by Scriptores Historiae Augustae, as well as by archaeological and epigraphical sources. Scriptores Historiae Augustae give the following information: "On the death of his wife Faustina, in the third year of his reign, the senate deified her, and voted her games and a temple and priestesses and statues of silver and of gold. These the Emperor accepted and furthermore granted permission that her statue be erected in all circuses;"[11]. The Fasti Ostiensis mention a statue for Diva Faustina[12], and the majority of her statue bases seem to date posthumously. Furthermore the six portraits

found in dated contexts all date posthumously[13] and the posthumous coins highly outnumber the coins struck in her honour during her lifetime[14]. It is probably therefore safe to assume that a substantial number of the portraits of Faustina Maior were erected posthumously.

Notes:

In Blundell's Account: *132. Sabina:*
Was Empress and wife of Adrian. Though celebrated for many virtues, yet by some improper behaviour, she so exasperated Adrian, that he behaved to her with great cruelty, and it was said, poisoned her, after they had been married thirty eight years, that she might not survive him. The character of this head is well known from the busts of her in the Capitol, as also from medals.

One of the busts meant is possibly the Faustina Maior in Museo Capitolino, Stanza degli Imperatori 27, which is a copy of the same type as Blundell's Faustina Maior. It is apparently mentioned as early as 1703 and entered the Museo Capitolino from the Albani Collection. It does, however, not seem to have been known as Sabina, see Fittschen/Zanker *III* p.13 no.13.

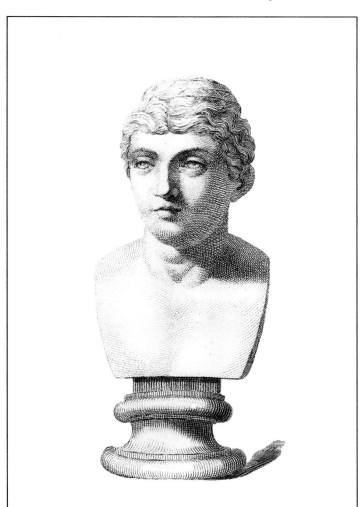

Figure 15. *Fragmentary portrait of Empress Faustina Maior restored as a bust. Cat. no.4. Ince 132. Engr. 61,1.*

1. S. Howard in Howard, *op. cit.* fig. 207, illustrates a photograph of the Ince Faustina Maior portrait but in the text, Howard p.82, he obviously refers to and describes another female head from Ince (Ashmole no.95 or 175). Also, there is no evidence at all for the Ince Faustina Maior portrait having gone through Cavaceppi's Studio.
2. See Wegner, *Herrscherbild Ant. Zeit.* p.26 ff.
3. For a detailed description of the type and for the two other Faustina Maior types, see Fittschen, *Erbach* p.81 ff.
4. See Fittschen, *Erbach* pp.81–82, nos. 19–23, and 26 for replicas found in contexts assuring the identification with Faustina Maior.
5. See Fittschen/Zanker *III* p.14 no.13.
6. At least on nos. 4, 5, 9, 11, 12, 14, 16, and 17 in Fittschen's list in Fittschen, *Erbach* p.81.
7. Nos. 1, 11, 14, and 16 in Fittschen, *Erbach* p.81.
8. However, the Erbach replica has no parting behind the left ear.
9. See Fittschen/Zanker *III* p.16 no.16. Also M. Wegner in Wegner, *Herrscherbild Ant. Zeit.* p.28, dates some of the Faustina Maior portraits during her lifetime on stylistic grounds, but here ''unruhigen Kräuselung und Auflockerung des Stirnhaares'' as he sees on the Chatsworth head and a head in the Conservatori Palace are signs of a posthumous dating.
10. See also *Geschichter* p.139.
11. Scriptores Historiae Augustae, Antonius Pius VI, 7 Loeb Ed.
12. See Calza, *Ostia. I ritratti.* I p.91.
13. See Fittschen, *Erbach* pp.81–82, nos. 19–23, and 26.
14. See *BMC Coins* IV, Antoninus Pius to Commodus pp.XL–XLII.

Catalogue 5

Ince no.515. White marble portrait of a woman restored with statue of black marble.

Total height including base: 1.8m.; height of statue from shoulder to base: 1.39m.; height of inserted piece (i.e. head with neck): 0.38m.; height from chin to hairline: 0.155m.

Marble: head: white, fine-crystalled;
statue: grey to black, probably Nero antico[1].

Restored, head: no restorations. Damage to tip of nose. Surface: face entirely worked over and thereafter probably treated with acid to simulate encrustation on right cheek and in front hair.

Restored, statue: hand and both feet (in light yellow fine-crystalled marble which is different from that of head), part of drapery above feet, some large and several smaller patches of drapery. Damage: The statue is broken at the waist and at the base of the veil. Large scratches on the back.

Lit.: Lord Cawdor's Sale. Auction Skinner and Dyke (1800)[2]; Blundell Acc. 515 and Blundell Eng. 37; Clarac V no.2458 pl.955; Waagen, *Treasures in Great Britain.* Vol.III. London (1854) p.258[3]; Michaelis, *Priv.* p.26 no.51; Michaelis p.354 no.51; Bernoulli II 2 p.153 no.4; A. Furtwängler, *Über Statuenkopien im Alterthum.* Munich (1896) p.39; Reinach-Clarac p.589: G. Lippold, *Kopien und Umbildungen griechischer Statuen.* Munich (1923) p.143 and 222; Ashmole p.28

no.51; Wegner, *Herrscherbild Ant. Zeit.* p.156; G. Lippold, *Die griechische Plastik. Handbuch der Archäologie III 1.* Munich (1940) p.290 note 7; Vermeule/ von Bothmer, p.157; H.-J. Kruse, *Römische weibliche Gewandstatuen des 2. Jahrhundert n.Chr.* Diss. Göttingen (1975) p.172 and p.371; A. Linfert, *Kunstzentren hellenistischer Zeit. Studien an weiblichen Gewandfiguren.* Wiesbaden (1976) p.54 note 156; Wegner, *Vz. I* p.126; Fittschen/Zanker *III* p.71 no.94.

Purchased from Lord Cawdor's sale.
Displayed at Ince in the Greenhouse.

The statue is one of the most impressive from the Ince Blundell Hall Collection, because of the effective and rare[4] combination of the two materials[5]. The following technical details indicate, however, that the head may not belong to the statue: the head seems to have been re-cut to fit into the veil (parts of both ears and part of a plait on the top of the hairstyle have been cut off); the hairstyle is carefully executed at the nape of the neck where it is hidden by the veil; and the back of the veil is formed after a quite different hairstyle, probably one with a low classical knot-type, "krobylos"[6].

The head which is about life-size was apparently re-cut with a punch very roughly on the back (in the 18th century?) to fit into the veil[7]. It shows a woman with a "tower" hairstyle similar to that worn by Faustina Maior (cf. cat. no.4). The front hair is combed backwards in crimped waves from either side of a central parting, leaving the ears free. It falls low over the forehead and forms an almost straight hair-line. On the crown of the head is the characteristic "tower" bun. The transition between front hair and bun is marked by two twisted strands of hair which form a large knot over the middle of the forehead.

Fittschen has observed that the Ince portrait and a portrait in the Villa Borghese are replicas. The two portraits show exactly the same hairstyle, with some unusual details[8], and the physiognomic differences between the two portraits are probably explained by the heavy reworking on the Ince portrait[9]. Fittschen's date of the Capitoline head to about 140 A.D. must apply to the Ince portrait too.

The statue copies a Hellenistic type[10] and is dated by Kruse to the early Antonine period (i.e. contemporaneous with the inserted head). This date may have been influenced by the style of the portrait, as the closest stylistic parallel mentioned by Kruse is Hadrianic[11]. The statue is therefore, probably Hadrianic or early Antonine (i.e. A.D. 125–150) combined with an idealised head[12], whereas the combination

with a portrait head has parallels in the 18th century[13].

Notes:

In Henry Blundell's Account: *515. Faustina.*
This statue, about the size of life, is singular on account of its drapery being in Lesbian marble (an opaque basalte) with the folds in high taste. The head which is esteemed a fine portrait of that empress, is of Parian marble, as also the hands and feet. She was the wife of Marcus Aurelius, and is noted in history for her intrigues, debaucheries etc.

Figure 16. *White marble portrait of a woman restored with a statue of black marble. Cat. no.5. Ince 515. Engr. 37.*

1. See R. Gnoli, *Marmora Romana.* Rome (1971) p.165.
2. See "A Catalogue of a most noble, capital, and valuable Collection of antique marble statues and bustoes, with a choise and matchless

selection of Etruscan vases, the whole forming a very interesting and magnificent Gallery, the property of the Right Ho. Lord Cawdor, collected with great judgement, taste and liberality, during several years residence in Italy sold by auction by Mess. Skinner and Dyke, on Thursday the 5th and Friday the 6th of June 1800.''.

"Second Day's Sale
67. An interesting figure of Faustina, the drapery in Lesbian marble".
The statue was bought by Blundell for 30 guineas.

3. It is possibly the statue in the Greenhouse described by Waagen in the following way: "A female statue, also with a head not belonging to it, and of bad workmanship. The drapery, though of commonplace execution, is striking from the peculiarity of its cast", see Waagen, *op. cit.*

4. For the use of coloured stones in the Roman period, see R. Schneider, *Bunte Barbare.* Worms (1985) p.158 ff. and H. Mielsch, *Buntmarmore aus Rom im Antikenmuseum Berlin.* Berlin (1985) p.23 ff.

5. So Fittschen in Fittschen/Zanker *III, op. cit.*

6. For an example of a statue with the hairstyle of a separately made head reflected on the back of the veil, see Zanker in Fittschen/Zanker *III* p.1 no.1. This is however not the rule, and the mechanical production of statues for portrait heads weakens this argument.

7. It has not been possible to take the head out due to the fragmented nature of the veil. According to the Conservation Department in Liverpool Museum, which was responsible for the reassembling of the statue in 1975, it is remembered that the head was very roughly hacked off on the back.

8. The knot in the front hair is unusual in this period. A similar knot is seen in the Hadrianic period, see for example a grave relief in Wrede, *Consecratio* p.284 no.238 pl.34, 2, and for Sabina, see A. Carandini, *Vibia Sabina.* Florence (1969) p.78 no.173, and also in C. Vermeule, *Greek and Roman Sculpture in America.* California (1981) p.314 no.270. There are also examples from the mid first century A.D., see a grave relief in Museo Nazionale delle Terme in A. Giuliano, *Museo Nazionale Romano. Le Sculture* I.2. Rome (1981) p.237 no.33.

Several private portraits of the Antonine period are seen with a hairstyle similar to that of the Ince and Capitoline heads, but without the characteristic knot in the fronthair. These portraits are all closely related to the portraits of Faustina Maior, see the list in Fittschen/Zanker *III* under nos. 89, 95, and 96.

9. See above under "*Restored, head . . . Surface*". The lower part of the face has suffered heavily and only the deeply set eyes, the straight eyebrows, and the aquiline nose reflect the ancient features. Individual strands of hair along the hair-line are cut off abruptly (compare with the Capitoline head) and show that the hair-line is a modern cutting. Also the drilled channels separating ears from hair seem modern. A stylistic and physiognomic close parallel to the Ince portrait is found in a portrait in Boston, see C. Vermeule/M. Comstock, *Sculpture in Stone.* Boston (1976) p.227 no.358. Also the portrait in Evora, Spain, see A. Garcia Y Bellido, *Esculturas Romanas de Espana y Portugal.* Madrid (1949) p.75 no.60 pl.55, listed in Fittschen/Zanker *III* p.72 no.95 list h.

10. See R. Horn, *Stehende weibliche Gewandstatuen in der hellenistische Plastik, RM Ergz.* 2 (1931) p.87, Kruse, *op. cit.*, and Linfert, *op. cit.*, for the three other replicas copying the same original. The replica in Izmir also had a veil, see *ÖJH* 27 (1932), Beibl. 50, while the Borghese replica was executed without a veil. The three published statues each had separate inserted heads.

11. Kruse, *op. cit.* p.172.

12. The combination of a female body in black marble with an idealised head in white marble is not unusual, see for example the Demeter statue in Florence, Mansueli, *Galleria degli Uffizi* I pp.61–62 no.38.

13. See G. Heres, "Kaiserserien in den Kunstkammern des Baroch", in *Römische Porträt Wege zur Erforschung eines gesellschaftlichen Phänomens. Wissenschaftliche Zeitschrift der Humbolt-Universität zu Berlin* 213 (1982) p.210.

Catalogue 6

Ince no.54. Portrait statuette of a woman with attributes of Fortuna.

Total height: 0.73m.; depth at base: 0.45m.; height of head: 0.144m.; height from chin to hair-line: 0.093m.

Marble: white, fine-crystalled with black veins.

Restored: most of cornucopia (except for small piece at the left arm) with part of back of throne, left arm (from sleeve) with lower part of cornucopia and hand (all missing), right arm (from sleeve) with hand and handle of rudder, and patch on drapery above left foot (missing). Damage to tip of nose, top of diadem, left foot, and in places to drapery. Surface: varies. Back smooth, front very weathered and rough. A crack runs across the middle of the figure and goes deeply into the stone. Other similar but smaller cracks.

Lit.: Blundell Acc. 54 and Blundell Eng. 44,1 and frontispiece; Clarac. III no.834A pl.454; Michaelis, *Priv.* p.22 no.7; Reinach-Clarac p.223; Michaelis p.338 no.7; Ashmole p.5 no.7; H. Wrede, "Das Mausoleum der Claudia Semne", in *RM* 78 (1971) pp.164–165; Wrede, *Consecratio* p.234 no.109.

Purchased from Villa Borioni[1].
Displayed at Ince outside in a niche in the Pantheon porch, later in the Garden Temple.

The placing of the statuette in a niche outside was probably the reason for the differences in the surface. Variations in temperature probably caused the deep cracks in the stone. The statuette is cut in one piece and the head is unbroken from the body[2]. She sits on a throne in a majestic pose twisted a little to the left and with both feet resting on a low stool. She wears chiton, mantle, sandals, and in her hair diadem and fillet. In the left hand she holds a cornucopia[3] and in the right hand a rudder resting on a globe.

The body copies a common Fortuna type used for coins, terracottas, bronzes, sculpture etc. throughout the Roman Empire[4], whereas features of the head and the fashion hairstyle in particular show individual portrait character. The face is that of a young woman with long narrow eyes and a tight, slightly sulky mouth. The front hair is on either side of a parting arranged in four S-shaped locks which are drawn around a fillet visible above the middle of the forehead. The locks are then taken to the back of the head and together with the rest of the hair made into a long thin plait which is gathered into a high placed knot.

The dating of the statuette must be close to A.D. 147–148[5] when Faustina Minor wore an almost identical hairstyle[6].

The carving is mediocre and unpretentious: the rendering of drapery is without inner volume and plasticity and details of mantle, rudder, stool etc., are treated more like relief sculpture than sculpture in the round. Furthermore, the head has a slightly unfinished appearance as the details in hairstyle and physiognomy are sketchily indicated and lack a finishing touch.

Neither Poulsen, Vermeule, nor Wegner have paid any attention to the statuette or indeed to Michaelis' and Ashmole's identification of it as Faustina Minor represented as Fortuna, and with good reason as observed by Wrede[7]. The identification with Faustina Minor is improbable: firstly, details in hairstyle and physiognomy deviate considerably from portraits of Faustina Minor; secondly, other similar and contemporaneous statuettes/statues are possibly correctly interpreted as private deifications/grave portraits[8]; and thirdly, the unfinished appearance may indicate an original grave context[9]. Most probably, the statuette is a private deification which functioned as a grave portrait[10].

Figure 17. *Portrait statuette of a woman with attributes of Fortuna. Cat. no.6. Ince 54. Engr. 44,1.*

Notes:

In Blundell's Account: *54. Fortuna Navalis.*
This figure holds in one hand a rudder, and in the other a cornucopia, from whence it is called Fortuna Navalis, or the Goddess of commerce, plenty and riches. All such Goddesses are held in great veneration amongst the ancients. It was bought in a lot out of the Borrioni Villa.

1. Not included in Venuti's catalogue, "Collectanea Antiquitatum Romanarum quas centum Tabulis Aenis incisas et a Rudolphino Venuti academico etrusco cortonensi notis illustratas exhibet Antoninus Borioni". Rome (1735).
 For the Borioni villa and its collection of ancient sculpture see Gerard Vaughan (forthcoming in this series).
2. Wrede in Wrede, *Consecratio* p.234, expressed doubt about the authenticity of the head on the basis of the existing photographs.
3. There can be no doubt that the restoration of the cornucopia in the left hand is correct as the statuette follows a well known Fortuna type, see note 4.
4. For the Tyche from Antiochia by Eutychides as prototype, see H. Schoppa, in *Germania* 11 (1938) p.240 ff.
 For the type on coins see for example *BMC Coins* IV pl.55, 7, a Faustina Minor denarius and I. Kajanto, "Fortuna" in *Aufstieg und Niedergand der römischen Welt. Geschichte Roms im Spiegel der neueren Forschung.* ed. H. Temporini and W. Haase, vol. II, 17.1 (1981) p.518–521.
 For terracottas, see G. Schauerte, *Terracotten mütterlicher Gottheiten.* Cologne (1985) pp.20–21 and pp.204–205.
 For statuettes in stone, see E. Paul, *Wörlitzer Antiken.* Wörlitz (1965) p.38 fig. 20.
5. Other contemporary portraits, both private and official, show a similar fillet above the forehead, see for example Wyndham, *Petworth* p.112 no.69, and Fittschen, in Fittschen, *Bildnistypen* p.59, the seventh Faustina Minor type, variation B, and Fittschen in Fittschen, *Bildnistypen* (1982) p.53 note 34, C1–C2.
6. Faustina Minor did not wear a fillet. For the date of Faustina Minor's first portrait type, see Fittschen in Fittschen, *Bildnistypen p.38–39 and p.47 and Fittschen/Zanker III* pp.20–21 no.19.
 On both the Ince statuette and the Leconfield head the fillet is ornamented with two knots/rosettes? which may show influence also from the official portrait, see the so-called "Stirn-Haar Rosetten-type" of Faustina Maior see Fittschen/Zanker *III* p.17 no.17.
7. See Wrede, *Consecratio* p.234 or indeed later Fittschen in his works on Faustina Minor.
8. See Wrede, *Consecratio* p.233 ff. for other Fortuna deifications. Further a statuette in the Museo Torlonia which portrays a woman with attributes of Ceres. The hairstyle is similar to the Ince statuette, the quality is mediocre, and it is said to have been found on the Via Appia, see L. Visconti, *I Monumenti del Museo Torlonia.* Rome (1885) p.236 no.358 pl.88.
 For the problematic Mars and Venus group in the Capitoline Collections I take D.E.E. Kleiner's view that it represents private individuals: firstly, the hairstyle of the woman shows the same knot as the Ince statuette, and not the typical ring-shaped bun worn by Faustina Minor, and secondly the group was found on the Via Sacra. See D.E.E. Kleiner, "Second-century mythological portraiture: Mars and Venus", in *Latomus* 40 (1981) pp.512–544 and Kleiner's review of Fittschen/Zanker *III* and Fittschen/Zanker *I* in *AJA* 90 (1986) p.371.
 For the identification with Marcus and Faustina, see Fittschen in Fittschen/Zanker *I* pp.69–70 no.64.
9. For unfinished portraits on Roman sarcophagi see B. Andreae, "Bossierte Porträts auf römischen Sarkophagen – ein ungelöstes Problem", in *Symposium über die antiken Sarkophagen*, Marburger Winckelmann Program (1984) p.109 ff.
10. Also H. Wrede, in Wrede, *Consecratio* p.234, although he considered the head dubious.

Catalogue 7

Ince no.108. Portrait of a woman restored on an ancient? bust.

Total height: 0.75m.; height of head with preserved part of neck: 0.27m.; height from chin to hair-line: 0.149m.; height of bust: 0.41m.

Marble: head: white, fine-crystalled;
 bust: yellow, medium-crystalled.

Restored, head: nose with surrounding area, both ears with large pieces of hair in front, three patches on neck, bust and base. Damage to back of hair. Several recent impact marks (from shot-gun pellets?) on face. Surface: encrustation and traces of roots in hair. Face severely cleaned and many details lost. The front hair has a rather biscuit-like appearance and is worked over.

Restored, bust: several small patches on drapery, and base with index-plaque.

Lit.: Blundell Acc. 108 and Blundell Eng. 51, 2; Michaelis, *Priv.* p. 27 no.91; Michaelis p.360 no.91; Poulsen p.92 no.78; Ashmole p.43 no.91 ; Ashmole, *Guide* p.22; Walker Art Gallery, *A Selection from the Ince Blundell Hall Marbles.* Liverpool (1961) p.16 no.24; Calza, *Ostia. I Ritratti* I p.97 no.156; R. Calza, *Antichita' di Villa Doria Pamphilj.* Rome (1977) pp.285–286 no. 354 note 5; Howard p.79; Fittschen/Zanker III p.70 no.91 no.f.

Purchased from Bartolomeo Cavaceppi, and said to have been found in Ostia.
Displayed at Ince in the Garden Temple.

The head is slightly under life-size and was originally turned to the right. The structure of the neck shows, however, that the present turn of the head is greatly exaggerated. The woman portrayed wears a ''tower'' hairstyle: the front hair is separated from the rest of the hair by a thick plait and probably consists of two long strands of hair which are arranged in five S-shaped locks on either side of a central parting. The S-shaped locks are wound around two twisted strands of hair which are visible only above the middle of the forehead. A kind of bow is probably formed by the ends of the two centre S-shaped locks. The hair at the back is combed into a high ''tower'' nest. This type of hairstyle is closely related to that worn by Faustina Maior (cf. here no.3), especially in the so-called ''Stirnhaar-Rosetten''-type[1]. A variant of it is seen on a colossal portrait in Tripolis[2], where S-shaped locks in the front hair are combined with a ''tower'' nest. The Ince portrait is, therefore, to be dated to the early to middle Antonine period (i.e.

A.D. 140–160) as previously suggested by Poulsen, Ashmole, Calza, and Fittschen. A very similar hairstyle is found in a substantial number of private portraits both in sculpture in the round and on grave reliefs[3]. Some of them also have the typical bow over the middle of the forehead[4] which perhaps may allude to Venus. Information given by Blundell that the head was found in Ostia[5] may well be correct: sculptures from Ostia often show a similar heavy encrustation as observed on the back of the Ince portrait[6] – and there are similarities in the structure of the head, and details of the hairstyle for example, to a statue in the Vatican Museums, Chiaramonti 546, also found in Ostia[7]. At the time of Blundell's acquisitions[8] excavations were conducted in Ostia for example by Winckelmann around 1763[9] and by Gavin Hamilton in 1774[10].

Ashmole, in 1929, regarded the bust as basically ancient, but re-cut from a whole statue and foreign to the head. According to Howard[11], Ashmole later expressed doubt about the authenticity of the bust and reached the conclusion that the bust was either totally worked over or entirely modern. The excellent carving and the many carefully executed restorations suggest that the bust is ancient.

Notes:

In Blundell's Account: *108. Marciana.*
This is in fine Greek marble. The drapery of it is remarkably fine; and the whole superior to any bust known of that empress. She was sister to the emperor Trajan, and, on account of her many virtues was declared empress. Found at Ostia, and bought through Cavaceppi.

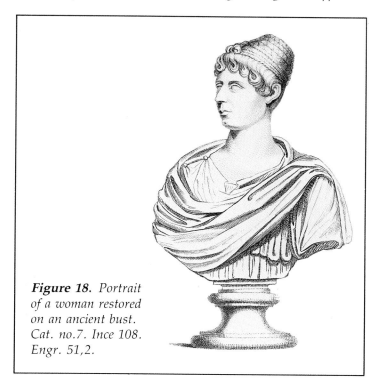

Figure 18. Portrait of a woman restored on an ancient bust. Cat. no.7. Ince 108. Engr. 51,2.

1. See here under no.3.
2. See Fittschen/Zanker *III* Beilage 13c.
3. See the list in Fittschen/Zanker *III* p.70 no.91.
4. For portraits in Rome, Villa Doria Pamphilj, see R. Calza, *Antichita di Villa Doria Pamphilj.* Rome (1977) p.285 no.354 pl.192; Rome, Museo Nazionale delle Terme see DAI Inst. Neg.84.8077; Florence, Galleria degli Uffizi, see Mansuelli, *Galleria Uffizi* II p.99 no.115; Florence, Galleria degli Uffizi, see Mansuelli, *Galleria Uffizi* II p.141 no.189; Ostia Museum, see Calza, *Ostia Ritratti* I p.96 no.155 pl.92. Rome, Palazzo Torlonia, see C.L. Visconti, *I Monumenti del Museo Torlonia.* Rome (1885) p.213 no.312 pl.78; Leningrad, Hermitage Museum, see *Musee de l'Ermitage, Le Portrait Romain.* Leningrad (1974) p.171 no.49; Los Angeles County Museum, see M. Milkovich, *Roman Portraits. Exhibition Worchester Art Museum.* Worchester (1961) p.50 no.21; a grave relief in Rome, Vatican Museums, Chiaramonti 500, see Amelung I p.642 no.500 pl.69.
5. See Blundell Acc. above.
6. I owe this observation to Flemming Johansen.
7. See Calza, *Ostia. I Ritratti* I p.98 no.159.
8. His first antiquity was acquired in 1777, see Introduction. When exactly this portrait was purchased is not known.
9. See C. Justi, *Winckelmann und seine Zeitgenossen.* Leipzig (1898) vol. III no.19: "In den Ruinen des alten Ostia liess ich Verschiedene Versuche mit Nachgrabungen machen . . ."
10. Thieme-Becker, Künstlerlexicon.
11. See Howard p.79.

Catalogue 8
Ince no.107. Portrait of a woman restored on an ancient? bust.

Total height: 0.69m.; height of head with preserved part of neck: 0.25m.; height from chin to hair-line: 0.176m.; height of bust: 0.35m.

Marble: head: white, fine-crystalled;
bust: slightly yellow, fine-crystalled.

Restored, head: tip of nose with most of both nostrils, and patch on bridge of nose (all repaired in plaster). Damage: recent impact marks (from shot-gun pellets?) on left cheek, mouth, eyebrows and forehead. Surface: cleaned, but not deeply.

Restored, bust: part of drapery at the neck, large pieces on both shoulders, several smaller restorations on drapery, most of index-plaque (except for upper profile) with base.

Lit.: Blundell Acc. 107 and Blundell Eng. 52,2; Michaelis, *Priv.* p. 27 no.93; Michaelis p.360 no.93; Poulsen p.101 no.94; Ashmole p.44 no.93; Ashmole, *Guide* p.22; B.M. Felletti Maj, *Muzeo Nazionale Romano, I Ritratti.* Rome (1953) pp.131–132 no.259; A. Giuliano, *Catalogo dei Ritratti Romani del Museo Profano Lateranense.* Citta del Vaticano (1957) p.64 no.73; K. Buchholz, *Die Bildnisse der Kaiserinnen der severischen Zeit nach ihren Frisüren (193–235 n.Chr.).* Diss. Frankfurt am Main (1963) p.138; Meischner *Diss.* p.147 no.58; J. Meischner, "Privatporträts der Jahre 195 bis 220. n.Chr.", in *JdI* (1982) p.434 and p.436; Fittschen/ Zanker *III* p.101 no.148 note 5; K. Fittschen,"Über Sarkophage mit Porträts verschiedener Personen", in *Marburger Winckelmann Programm* (1984) p.158 note 14.

Purchased from Villa Borioni[1].
Displayed at Ince in the Garden Temple.

The portrait is about life-size and was originally turned to the right similar to the way it is now fitted to the alien bust. The hairstyle is a variant of the characteristic Severan "helmet" type, here consisting of three basic elements: a broad loosely twisted strand of hair surrounding the face and covering the ears; behind this, thinner ribbed strands of hair (seven on the right side and eight on the left side of the head); finally a large plaited bun covering the whole back part of the head. The face is long and narrow with prominent cheekbones and a small pointed chin. The hair-line and the sharply pronounced eyebrows which meet above the nose give the forehead a triangular shape. The large distinct pupils of the eyes touching the upper lids direct the gaze to the right.

The soft modelling of cheeks and chin gives a clear idea of the bone structure and owes much to the Antonine tradition, whereas the distinct rather flat treatment of the eyelids and the sharp eyebrows is stylistically closer to portraits of Julia Domna of the Gabii type[2]. This combination of a gentle modelling of flesh with a rather hard treatment of eyes and eyebrows is also found, for example, in a portrait in Museo Capitolino[3], dated to the early Severan period (i.e. A.D. c.200). The Ince portrait should be dated accordingly[4]. Close to the Ince portrait in style also, is a portrait in Cincinnati[5]: it shows the same rendering of the front hair with a careful, linear, somewhat dry incision.

A portrait of a woman on a sarcophagus, formerly at Hever Castle[6], is close to the Ince portrait in hairstyle and physiognomy. It is therefore tempting to assume that they might represent the same person[7]. However one should be aware that the sarcophagus portrait does not show any significant physiognomy and that several other private portraits show a similar hairstyle[8].

The bust seems foreign to the head but is probably ancient[9]. The size, the draping of the mantle over the left shoulder, and the simple arrangement of the folds, with no clear distinction in texture between mantle and tunic, date it to the late Antonine or early Severan period[10].

Notes:

In Henry Blundell's Account: *107. Didia Clara.*
Busts of this empress are very rare, and remarkable for their head-dress. One, similar to this, is to be seen in the Florentine Gallery. Didia Clara was the only daughter of Didius Julianus, and accounted extremely handsome, but her private character is little known. This was bought out of the Villa Borrioni.

Possibly the bust inscribed with "Didia Clara" in Florence, Galleria degli Uffizi, inv. 1914, n.205, known at least from the early 18th century, see Mansuelli, *Galleria Uffizi* II p.112 no.137.

Figure 19. *Portrait of a woman restored on an ancient? bust. Cat. no.8. Ince 107. Engr. 52,2.*

1. For the sculpture in the Ince Blundell Hall Collection from Villa Borinu, Rome, see G. Vaughan (forthcoming in this series).
2. See R. Schlüter, *Die Bildnisse der Kaiserin Julia Domna.* Diss. Münster (1971) p.57 ff.
3. See Fittschen/Zanker *III* p.97 no.141 pl.168.
4. The same dating is also given by Michaelis, Poulsen, Ashmole, and Fittschen, while Meischner in *JdI* (1982) p.434, suggests the following date: "in der ausgehenden Epoche Caracallas".
5. See C. Vermeule, *Greek and Roman Sculpture in America.* California (1981) p.344 no.296 with previous references, and colour plate 27. Schlüter in R. Schlüter, *Die Bildnisse der Kaiserin Julia Domna.* Diss. Münster (1977) p.132, expressed doubt about the authenticity of this head.
6. See Oehler, *Foto* p.65 no.48 pl.64a with previous references, and Fittschen in *Marburger Winckelmann Programm, op. cit.*

7. Fittschen first compared the Ince portrait with the portrait on the sarcophagus from Hever Castle. Also from the Severan period is a portrait in Rome, Museo Nazionale delle Terme, inv.564, of the same private individual whom K. Schauenburg has recognised on a sarcophagus relief in Frankfurt, Liebighaus, see his article, "Perückträgerin in Blattkelch", in *Städel Jahrbuch* 1 (1967) pp.47–48 figs. 1–4.
8. For a list of portraits with tripartite hairstyle with ribbed strands of hair, see Fittschen/Zanker *III* p.101 no.148, note 5. See also a portrait in Parma, in A. Frova/R. Scarani, *Parma Museo Nazionale di Antichita.* Parma (1965) p.16 no.2 pl.2. See a portrait in a Danish private collection, *Antik Kunst i dansk Privateje.* Exhibition Ny Carlsberg Glyptotek Copenhagen (1974) p.51 fig. 321. Further a portrait in Heidelberg University, Institute of Archaeology, unpublished, and portraits in Izmir and Konya, see J. Inan/E. Rosenbaum, *Roman and early Byzantine Portrait Sculpture from Asia Minor.* London (1966) p.115 no.123 pl.74 and p.83 no.57 pl.36.
9. Poulsen regarded the bust as modern. However, I agree with Ashmole that it is ancient.
10. For busts of this period, see Fittschen/Zanker *III*, particularly under nos. 138 and 145.

Catalogue 9
Ince no.7. Portrait of a woman restored on an ancient statue.

Total height: 2.05m.; height of ancient parts (i.e. excluding plinth): 1.95m.; height of statue excluding plinth: 1.70m.; height of head with bust: 0.335m.; height from chin to hair-line: 0.189m.

Marble: head: white, fine-crystalled;
statue: white, fine-crystalled, but different from head.

Restored, head: patch on both eyebrows, nose with central part of mouth, most of two curls on the right side of the neck from below chin level (see fig. 20 curls nos. 3 and 4 but with the end of curl 3 or 4 preserved on the bust), and two curls on the left side of the neck below chin level (curls nos.2' and 3'). Damage to eyes, cheeks, and chin. The foremost curl, of which part is preserved on the left cheek (curl no.4') was apparently never restored. Part of a curl (no.2) on the right side of the neck is missing and seems never to have been restored either (the end of curl 2 is preserved on the neck). Surface: heavy encrustation on the right cheek. The pupils are redone.

Restored, statue: both arms with attributes, front part of plinth except for piece under the right foot, left foot with part of drapery above, most of folds in himation hanging down the back, several small restorations on drapery, and a hole (diam. c.0.07m by the l. elbow) which runs right through the statue.

Lit.: Fontaniere, *Descrizione delle R. Villa Estense di Tivoli* (1725)[1]; Cartieri (1752–53)[2] ; Blundell Acc. 7 and Blundell Eng. 7; Clarac V no.2482A pl.965; A.

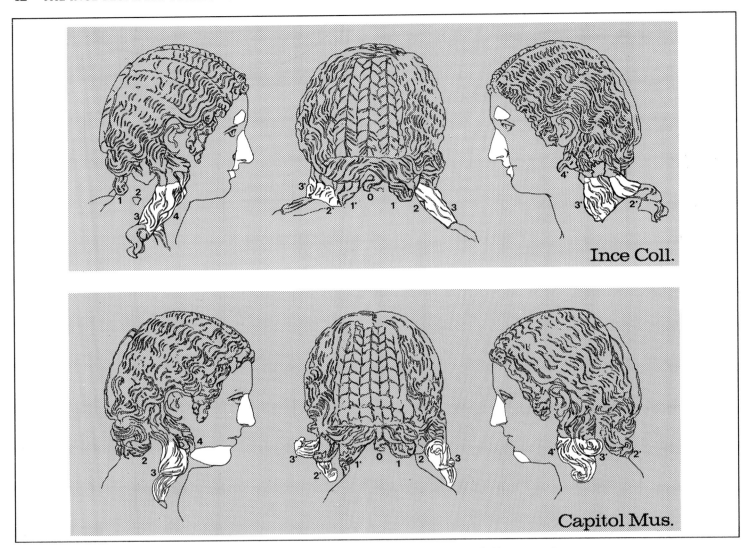

Figure 20. *Detail of restoration. Ince 7, Capitoline Museum 401. (Drawing by Poul Christensen).*

Conze, "Antikensamlungen in England", in *Archaeol-ogische Anzeiger. Zur archaeologischer Zeitung* 22 (1864) p.12; Bernoulli II 3 p.47; Michaelis, *Priv.* p. 26 no.52; H. Winnefeld, Die Villa des Hadrian bei Tivoli. *JdI Ergz.* 3 (1895) p.165; Reinach-Clarac p.593; P. Gusman: *La Villa Imperiale de Tibur*. Paris (1904) p.291; T. Ashby, "The Villa d'Este at Tivoli and the Collec-tion of Classical Sculptures which it contained", in *Archaeologia* 61 (1908) p.254; Michaelis p.354 no.52; Ashmole p.29 no.52; Ashmole, *Guide* p.15; H. Weber, "Zu einem Bildnis der Kaiserin Julia Paula", in *JdI* 68 (1953) p.132ff.; Vermeule/von Bothmer p.157; K. Buchholz, *Die Bildnisse der Kaiserinnen der severischen Zeit nach ihren Frisüren (193–235 n. Chr.)* Diss. Frank-furt am Main (1963) p.151; Meischner, *Diss.* p.155 no.82; Wegner, *Herrscherbild Caracalla* p.123; W.

Trillmich, *Das Torlonia Mädchen* (Abh. Göttingen 99 (1976)) p.79; M. Bergmann, *Studien zum römischen Por-trät des 3. Jahrhunderts n. Chr.* Antiquitas 3. 18 Bonn (1977) p.95 note 396; J. Raeder, *Die statuarische Aus-stattung der Villa Hadriana bei Tivoli.* Frankfurt am Main (1983) p.196 no.V9; J. Meischner, "Privatpor-träts des Jahre 195 bis 222 n.Chr.", in *JdI* 97 (1982) p.427 note 63; Fittschen/Zanker *III* p.109 no.163; J Meischner, "Privatporträts aus den Regierungsjahren des Elegabal und Alexander Severus (218–235)", in *JdI* 99 (1984) p.324 note 4.

Purchased from the Collection of the Duke of Modena, Villa d'Este[3], possibly through Jenkins[4]. Perhaps from Villa Hadriana[5].
Displayed at Ince in the Pantheon.

The head which is alien to the body is just over life-size and turned to the right and slightly downwards. The outline of the bust with the enlarged right side indicates that the head was designed for insertion into a statue or a bust.

The woman wears a so-called "Scheitelzopf" hairstyle with the hair parted in the middle and combed straight on either side of the parting before falling into six crimped waves. The ears are left free and at the back the hair is made into four separate plaits, pinned up together to form a flat bun ("Scheitelzopf") which covers most of the back of the head. Around the hair-line are small wispy curls, separated at the centre parting and continuing in longer locks in front of the ears. Long locks also fall behind the ears on the neck. The face is characterized by a high, rounded forehead, long flat cheeks, a broad fleshy chin, and a small mouth with slightly parted lips.

The portrait has recently been discussed in detail by Fittschen who has observed that the Ince portrait and a portrait in the Museo Capitolino are replicas[6]. The two heads show the same physiognomics, the hairstyles follow a strictly identical scheme[7] (see figure 13), and even the bust shapes seem identical. Ashmole suggested a mid third-century date for the Ince portrait by a convincing comparison with a portrait in the Vatican Museums, Braccio Nuovo 43[8]. This portrait should, however, be dated to the mid to late Severan period (i.e. A.D. 210–238)[9], a date which must apply to the Ince and Capitoline heads also[10].

The portraits do not correspond with any coin types of Severan empresses[11], and Fittschen assumes that they represent an important private individual. He has furthermore pointed out the slightly idealised, goddess-like appearance of the portraits caused by the long locks on the neck and the half-open mouth. It is possible that the portraits were mounted on statues of a Venus type which could account for these details[12].

The body is clad in a chiton with high placed belt and a large mantle. It is possibly a free Roman variation[13] of a typical Hellenistic theme[14].

The restoration with orbit and stylus into the muse Urania is totally unjustified. However, Urania, as muse of astronomy, became a general favourite of sculptors, painters, restorers, etc. from the Renaissance[15] into the 18th and 19th centuries. In 1774 the Museo Pio Clementino acquired from the Velletri Collection a Fortuna statue which was immediately transformed into a statue of Urania to fit into a desired muse group[16]. The Stockholm Muse Gallery dates to the 1780s[17], the Wörlitz muse group was acquired in Rome in 1796 through Jenkins[18], and Cavaceppi restored a statue from the Altieri Collection into Urania[19], etc.[20]. Urania and the muse of the heroic epic Calliope seem to have been particularly popular possibly because Plato stated them to be the oldest and most venerable of the muses[21]. In addition to the Urania statue in Ince, a statue of Calliope, now in Stockholm, possibly also came from the Villa d'Este[22]. The two statues might have represented yet another muse display – an 18th-century? paraphrase in the Villa D'Este of Plato's two most venerable muses[23].

Figure 21. *Portrait of a woman restored on an ancient statue. Cat. no.9. Ince 7. Engr. 7.*

Notes:

In Henry Blundell's Account: *7. Julia Pia.*
Was a lady from Phoenicia, celebrated for her great talents and learning. She came to Rome and by her personal charms, the emperor Septimius Severus became so enamoured, that he married her, and by

her had Caracalla and Geta. She applied much to the study of geometry and astronomy, in which she made such proficiency that she was mostly represented, as in this statue, in the character of the muse Urania, with a globe in one hand, and a style in the other. This statue displays a beautiful drapery, and elegance in the whole figure. It was bought from the Duke of Modena, out of his Villa d'Este at Tivoli, where it always attracted the notice of the intelligent antiquarians who visited that place. This statue, as well as most of the marbles at that villa, were collected by cardinal Hippolito, and were mostly found in the ruins of Adrian's villa. As that emperor was two years in Greece, it is supposed they were brought over by him, to ornament his villa, the greater part of them being in fine Greek marble.

1. The description and inventory list made by the then keeper of the fountains at Villa d'Este. See also below note 3 and Ashby, *op. cit.* p.223.
2. Cartieri, as cited by Ashby, *op. cit.*
3. The documents are somewhat ambiguous: the statue is not included in any of the early inventory lists of the Villa d'Este, cf. the list of Cardinal Ippolito II of 1540–1572 or of Fiorelli of 1575, see Ashby, *op. cit.* p.221, but it is probably the statue referred to as Julia Pia in the Fontaniere list of 1725 (for Fontaniere see above, note 1), see Ashby, *op. cit.* p.251. It is possibly also referred to in the Cartieri inventory of 1752–1753 as estimated to the value of 2.000 sc. together with four other sculptures, see Ashby, *op. cit.*, p.254. The sale of sculptures from the Villa d'Este began in 1752–1753.
4. See Ashby, *op. cit.* p.238 and 254.
5. The only evidence for the Villa Hadriana provenance is the fact that the statue was once in the Villa d'Este.
6. The similarity between the two heads was also pointed out by Bergmann, *op. cit.*
7. It does not appear clearly what is restored on the Capitoline head, so Fittschen, *op. cit.*: "Ergänzt:Enden der auf beiden Seiten hinter den Ohren herabfallenden Locken." It seems that the foremost lock on the right side of the neck (no. 4) is entirely preserved, and that the lock behind it (no. 3) is restored but with the end of the lock preserved on the bust, see fig 1.
8. Ashmole does not refer to Braccio Nouvo 96 as stated by Bergmann, *op. cit.*, but to Braccio Nuovo 43, Ashmole, *op. cit.* see Amelung I p.62 no.43.
9. See Fittschen/Zanker *III* p.109 no.163 note 3 no.e.
10. Wood has suggested a Gallienic date for the Capitoline portrait, see S.E. Wood, *Portrait Sculpture and Sculptors of Rome A.D. 218–260* (Diss. Ann Arbor 1981) p.433 no.78, whereas Meischner, *op. cit.*, Bergmann, *op. cit.* and Fittschen, *op. cit.* all convincingly argue, mainly on the grounds of the drill technique, that the portraits belong within the Severan period – Meischner and Fittschen prefer a mid-Severan date.
 For related portraits see the lists by Fittschen in Fittschen/Zanker *III* p.108 no.161 note 3 and 6, and by Meischner in Meischner, *Diss.* p.154 ff., and Meischner, *op. cit.* in *JdI* 97 (1982) p.427.
 See also a portrait in the British Museum in A. Smith, *A Catalogue of the Sculptures in the British Museum* Vol.III. London (1904) no.2009 pl.18, and a portrait in Petworth House, see Wyndham, *Petworth*, p.100 no.62 pl.62, and Oehler, *Foto* p.83 no.87 pl.55.
11. Only Julia Paula wears a hairstyle with a similar moderate size bun and on a few coin types she also wears it with loose locks around the hair-line, see J. Kent/N. Overbeck, *Die römische Münze*. Munich (1973) pls.98–99 nos. 421–422. The Capitoline/Ince heads, however, differ considerably from Julia Paula's coin types and an identification with Julia Paula seems unlikely.
12. Or they might simply copy another portrait mounted on a Venus-type statue. For similar hairstyles on idealised female portraits on sarcophagi reliefs see the sarcophagus in Pisa, Campo Santo in H. Jucker, *Das Bildnis in Blätterkelch*. Basel (1961) p.30 no.S3 pl.6 and the portrait on the so-called Balbinus Sarcophagus in C. Reinsberg,

"Der Balbinus-Sarkophag – Grablege eines Kaisers?" in *Marburger Winckelmann-Programm* (1985) pl.1.
 See also Wrede, *Consecratio* p.202 no.19: "Lange Schulterlocken sind Indizien für eine posthume Idealizierung oder gar Deifizierung".
13. I am grateful to Prof. Tonio Hölscher for his comments on this statue.
14. See for example J. Inan, *Roman Sculpture in Side*. Ankara (1975) p.98 ff. no.36 pl.45.
15. See E. Schröter, "Die Villa Albani als Imago Mundi" in Forchungen zur Villa Albani. *Frankfurter Forschungen zur Kunst* Berlin (1982) p.236 and note 194 for references.
16. See Visconti's enthusiastic description of it in E.Q. Visconti, *Museo Pio Clementino* vol. 1. Milan (1818) pp.213–215.
17. See H.H. Brummer, *The Muse Gallery of Gustavius III*. Stockholm (1972).
18. See E. Paul, *Wörlitzer Antiken*. *Wörlitz* (1965) p.5 ff. and p.75, and R. Lullies, *Charakter und Bedeutung der Antikensammlung des Fürsten Leopold Friedrich Franz*, in Antikensammlungen im 18. Jahrhundert, p.199 ff.
19. See H. Brising, *Antik Konst i Nationalmuseum Stockholm*. Stockholm (1911) p.63 pl.26. This information is not found in Brummer, *op. cit.* note 17 under "Urania" p.29. Cavaceppi or Bianconi also restored a statue in Potsdam into Urania, see Blümel, RB p.34 no.R80 pl.19.
20. Christina of Sweden's muse group, now in Madrid, Prado Museum, dates to the mid 17th century, see Brummer *op. cit.* note 17, p.33 ff, and Raeder, *op. cit.*, I 26–33. An Urania in Leningrad, Hermitage, comes from the Campana Collection together with other statues of muses, see Le Musee Imperiale de l'Ermitage, *Musee de la Sculpture Antique*. St. Petersburg (1901) p.145 no.305. Others are in the Louvre, see Clarac III no.1099 pl.339 and Reinach-Clarac p.172, Berlin, see Blümel, RB p.19, Rome, Museo Nazionale delle Terme, see A. Giuliano, *Museo Nazionale Romano. Le Sculture* I.2. Rome (1981) p.61 no.47. They all seem to have their attributes restored. For Urania on sarcophagi, see M. Wegner, *Die Musensarkophage*. Berlin (1966).
21. See Schröter, *op. cit.* note 15.
22. Brummer, *op. cit.* note 17 p.30 suggests that it might be the statue referred to as "seated nymph", see Ashby, *op. cit.* p.225. See also Raeder, *op. cit.* p.201 no.V 29.
23. The statue in the Ince Blundell Collection with the antique? inscription "Anchirrhoe" (see Ashmole no.37) is a copy of the "Terpsichore" muse type and also comes from the Villa d'Este. There is the possibility that this is another muse from this collection.

Catalogue 10

Ince no.115. Modern? portrait of a woman with diadem.

Total height: 0.325m.; height of head and bust: 0.25m.; height from chin to hair-line: 0.106m.

Marble: large-crystalled, probably Eastern.

Restored: nose, left ear, part of rim of right ear, bust, and base with index plaque. Damage: slight to top of diadem. Surface: soap-like and highly polished except for the back which is left rough.

Lit.: Blundell Acc. 115; Michaelis, *Priv.* p.28 no.169?; Michaelis p.369 no.167; Ashmole p.67 no.167; Howard p.82.

Purchased from Bartolomeo Cavaceppi.
Displayed at Ince in the Pantheon, later in the Billiard Room.

The portrait is slightly under life-size. It leans forwards and is turned to the right. The young woman wears a high diadem placed behind an elaborate toupee which consists of eight feather-like strands of hair. Beneath the toupee occur strands of "natural" hair which terminate in a curl in front of the ear. The crown of the head is covered by a big ring-shaped bun. Behind the ears the hairstyle is roughly indicated in feather strands, and at the nape of the neck is a large knot (either a "Zopfschlaufe" or a classical "Krobylos") from which a loose lock is emerging. The eyebrows are roughly incised and a coarse rather imprecise incision also marks pupil and iris. Tearducts are marked by drilling. Only the mouth shows some individual character with a pronounced cupid's bow and a thick lower lip.

A hairstyle consisting of both a ring-shaped bun on the crown of the head and a knot at the nape of the neck is quite unusual. There seem to be three possible explanations: Either, the head is reworked, apparently in the Trajanic/early Hadrianic period (i.e. A.D. 110–130)[1], from an earlier head/portrait[2]. Or an ancient head has been reworked into a portrait of an imperial? woman, eventually Sabina or Matidia[3], in Cavaceppi's Studio (Blundell writes that Cavaceppi "valued it very much")[4]. Or alternatively, the whole piece is 18th-century.

Several details point towards the second or third option: the surface has a soapy opaque polish, and the extremely soft, uncharacteristic modelling lies on the surface rather than inside the stone. Both diadem and toupee are cut almost in relief and the diadem is not clearly defined from the toupee or the bun. All these characteristics are found in a portrait of a woman in the Leconfield Collection at Petworth which is probably restored by Cavaceppi, if not entirely 18th-century[5]: for instance, the soft uncharacteristic modelling and the relief-like treatment of details. Moreover, both portraits have the same rendering of the front hair and the oblong contour of the face underlined by the shape of the diadem, and they both show the slowly curving join between bust and head[6]. Furthermore the head and restorations (i.e. nose, ear and bust) on the Ince portrait appear to be of the same typical large-crystalled marble.

The Ince head is probably basically 18th-century, whether reworked from an ancient core or entirely modern.

Notes:

In Blundell's Account: *155 Juno.*
So called from the diadem. The head is in Greek marble, and in great preservation. It was bought from Cavaceppi, who valued it very much.

1. A similar hairstyle is seen on a portrait in Museo Capitolino, identified by both Wegner and Zanker as Matidia, see Wegner, *Herrscherbild. Hadrian.* p.82, and Fittschen/Zanker *III* p.9 no.8.
 There are also portraits with a high toupee combined with a knot/"Zopfschlaufe" at the neck from the Hadrianic period, see A. Carandini, Vibia Sabina. Florence (1969) p.149 figs. 59–60, but here the ring-shaped bun is omitted.
2. From a classical type or a Julio-Claudian portrait, see for example, Inan/Alföldi-Rosenbaum, pp.203–204 no.175 pl.130.
3. Imperial because of the diadem and a certain physiognomic resemblance with portraits of Sabina.
 For the diadem worn by private women, see Wrede, *Consecratio* p. 75.
4. Howard finds the nose, bust and base modern, as well as the polished surface, see Howard p.82.
5. See Wydham, *Petworth* p.108 no.67. Restorations on the Leconfield head tentatively attributed to Cavaceppi by Carlos Picon, see Picon, *Cavaceppi* p.72 no.18.
6. The forward lean which gives the head a slightly neo-classical appearance is seen in another head in the Ince Collection, also restored by Cavaceppi, see Ashmole p.64 no.157.

Catalogue 11
Ince no.164. Modern portrait bust of Livia.

Total height: 0.59m.; height of head and bust: 0.41m.; height from chin to hair-line: 0.185m.

Marble: white, fine-crystalled with black veins, probably Carrara.

Lit.: Blundell Acc. 164 and Blundell Eng. 145,3; Michaelis, *Priv.* p. 28 no.143; Michaelis p.366 no.143; Poulsen p.19 no.143; Ashmole p.59 no.143; *WAG Catalogue* p.320 no.9110.

Purchased from the Villa Mattei[1].
Displayed at Ince in the Picture Gallery.

The bust was bought by Blundell as a modern portrait of Livia. Several details strongly suggest that the 18th-century sculptor used not only a sculpted portrait[2] but also a coin-type of Livia as a model. The following details all recall the so-called Justitia coin-type[3]: the high ornate diadem, the special type of bun at the nape of the neck, and the shape of the bust.

Seymour Howard suggests that the Villa Mattei Collection was enlarged with modern pieces for profit at the time of its dispersal through Cavaceppi and Jenkins in the 1770s[4]. Possibly the Livia portrait was made on that occasion, perhaps in Cavaceppi's Studio[5].

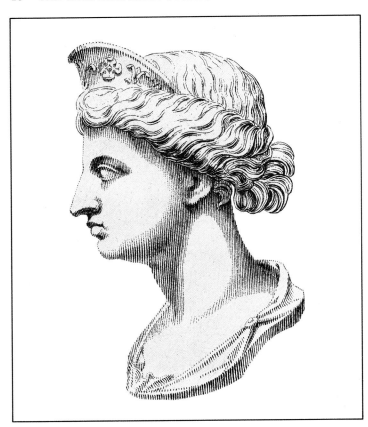

Figure 22. *Modern portrait bust of Livia. Cat. no.11. Ince 164. Engr. 145,3.*

Notes:

In Henry Blundell's Account: *164. Livia.*
This head is finely wrought: and though modern, deserves a place among reputable sculpture. Livia was wife of Claudius Nero, and mother of Tiberius. She was accused of great cruelties, even of the murder of her husband, in order to make room for her son Tiberius. She lived to the age of 86. Bought out of the Villa Mattei.

1. Not included in R. Venuti, *Vetera Monumenta Matthaeiorum* I-III. Rome (1776–1779).
2. A colossal portrait, according to Bernoulli, in Bernoulli II 1 p.106 no.14, of Livia based on the Pietas coin-type (with a veil) was in the Villa Albani in the period of Winckelmann. See A. Allroggen-Bedel, "Die Antikensammlung zu Zeit Winckelmanns", in Forrschungen zur Villa Albani. *Frankfurter Forschungen zur Kunst.* Berlin (1982) p.371 no.A525, in Marcelli-Fea-Visconti, *La Villa Albani.* Rome (1869) p.111 no.793.
3. There is a long discussion by Visconti in E.Q. Visconti, *Il Museo Pio Clementino* vol. II. Milan (1819) p.293 about the identification of the Salus, Justitia, and Pietas coins with Livia. Most recently on these Livia coin types, see Zanker in Fittschen/Zanker *III* p.3 no.3.
4. See S. Howard, "Bartolomeo Cavaceppi and the origins of Neo-Classical Sculpture", in *Art Quarterly* (1970) p.133 note 13.
5. Cavaceppi made a Livia for Schloss Wörlitz, see Zanker in Fittschen/Zanker *III* p.4 no.3.

Catalogue 12

Ince no.201. Modern portrait bust of Faustina Minor attributed to Bartolomeo Cavaceppi.

Total height: 0.56m.; height of head and bust: 0.47m.; height from chin to hairline: 0.165m.

Marble: white, fine-crystalled with black veins, probably Carrara.

Lit.: Blundell Acc. 201; Michaelis, *Priv.* p.29 no.189; Michaelis p.371 no.189; Ashmole p.72 no.189 or 189a (see below); S. Howard, "Bartolomeo Cavaceppi and the origins of Neo-Classical sculpture", in *Art Quarterly* 33 (1970) p.132 note 12; Fittschen, *Erbach* p.87 note 6b; *WAG Catalogue* p.293 no.6628; Wegner, *Vz. II* p.21; Howard p.27 and 83; Picon, *Cavaceppi* p.66.

Possibly purchased from Bartolomeo Cavaceppi. Displayed at Ince in the Picture Gallery.

A copy of the Faustina Minor bust in the Museo Capitolino, Stanza degli Imperatori 32, which was restored by Cavaceppi[1]. Howard has identified the Ince copy as one of many identical copies from Cavaceppi's Studio[2].

As pointed out by E. Morris[3], there is, however, uncertainty as to the identification of this bust within the Ince collection, because Ashmole identified another bust at Ince as a modern portrait of Faustina Minor. This might be the bronze bust now in a private collection, Ince no. 64 identified by Blundell as Livia.

Blundell considered it "a real portrait of her" (probably meaning ancient?) whereas the Livia portrait (cat. no.11) was described by him as "and though modern".

Notes:

In Henry Blundell's Account. *201. Faustina.*
From the medals of that empress, it appears to be a real portrait of her. She was wife of Marcus Aurelius, but a woman of very indifferent character. This was bought from Cavaceppi.

1. The Capitoline head was presented to Museo Capitolino by Pope Benedict XIV in 1748, see Fittschen/Zanker *III* p.20 no.19.
2. There is a list in S. Howard, "Bartolomeo Cavaceppi and the origins of Neo-Classical sculpture", in *Art Quarterly* 33 (1970) p.132 note 12. The copy formerly in the collection of the Duke of Northumberland, Syon House, now in Minneapolis Institute of Arts, is signed Bartolomeus Cavaceppi fecit Roma, see *WAG Catalogue*, p.293, and Picon, *Cavaceppi*, p.66.
3. See *WAG Catalogue, op. cit.*

MUSEUMS INDEX

Museum	Description	Reference
Boston, Museum of Fine Arts		
inv. 04.284	Antonine portrait	Cat. no.5 n.9
inv. 1979.556	Hadrianic statue	Cat. no.5 n.8
Carthage, Musée de		
	Hadrianic stucco reliefs	Cat. no.2
Cincinnati, Art Museum		
inv. 1964–5	Severan portrait	Cat. no.8
Erbach Castle		
	Hadrianic portrait bust	Cat. no.3 n.7
	Faustina Maior	Cat. no.4 n.3–4
Evora, Museu Archeologico da Cibdade de Evora		
inv. 103	Antonine portrait	Cat. no.5 n.9
Florence, Galleria degli Uffizi		
inv. 1914n.61	Antonine portrait	Cat. no.7 n.4
inv. 1914n.163	Antonine portrait	Cat. no.7 n.4
inv. 1914n.205	early Severan portrait "Didia Clara"	Cat. no.8 n.1
inv. 276	"Demeter" statue of black marble	Cat. no.5 n.12
Frankfurt, Liebighaus		
inv. 1502	Severan sarcophagus	Cat. no.8 n.6
Geneva, Musee d'art et d'histoire		
inv. 8119	Julia Titi	Cat. no.2 n.3
Geyre Museum		
inv. 68–341	Julio/Claudian portrait	Cat. no.10 n.2

Museum	Description	Reference
Heidelberg University Institute of Archaeology		
	early Severan portrait	Cat. no.8 n.7
Hever Castle, formerly		
	Severan sarcophagus	Cat. no.8
Izmir Museum		
inv. 537	early Severan portrait	Cat. no.8 n.10
inv. 649	statue, copy of	Cat. no.5 n.10
Konya Museum		
inv. 241	early Severan portrait	Cat. no.8 n.7
Lanckoronski Palais, formerly		
	Trajanic portrait	Cat. no.3 n.3
Leningrad, Hermitage		
	Antonine portrait	Cat. no.7 n.4
	Urania	Cat. no.9 n.20
Liverpool Museum		
Ashmole 154	portrait of a boy restored by Cavaceppi	Cat. no.3 n.10
Ashmole 157	boy as Mercury restored by Cavaceppi	Cat. no.10 n.6
Ashmole 196	portrait of Severus Alexander restored by Cavaceppi	Cat. no.3 n.10
London, British Museum		
inv. 2009	late Severan portrait	Cat. no.9 n.10
Los Angeles, County Museum		
	Antonine portrait	Cat. no.7 n.4

Museum	Description	Reference	Museum	Description	Reference
Madrid, Prado Museum			**Rome, Museo Capitolino**		
	nine muses	Cat. no.9 n.20	inv. 38	statue of Livia?	Cat. no.5 n.6
			inv. 209	Trajanic/Hadrianic grave altar	Cat. no.3
Minneapolis, Institute of Arts			inv. 401	Severan portrait	Cat. no.9
	Faustina Minor by Cavaceppi	Cat. no.12 n.2	inv. 449	Faustina Minor	Cat. no.12
			inv. 636	early Severan portrait	Cat. no.8 n.3
New York, Metropolitan Museum of Arts			inv. 647	Antonine portrait	Cat. no.7 n.3
inv. 22.139.2	Hadrianic portrait	Cat. no.10 n.1	inv. 449	Faustina Minor	Cat. no.12
			inv. 652	Mars/Venus group	Cat. no.6 n.8
			inv. 681	mid Severan portrait	Cat. no.8 n.7
Ostia Museum					
inv. 531	Antonine portrait	Cat. no.7 n.4	**Rome, Museo Capitolino**		
inv. 1058	marble toupee	Cat. no.2	Galleria 65	Trajanic grave altar	Cat. no.2 n.7
inv. 1931	marble toupee	Cat. no.2			
			Rome, Museo Nazionale Romano		
Paris, Louvre			inv. 564	early Severan portrait	Cat. no.8 n.6
	Urania	Cat. no.9 n.20	inv. 196633	grave relief 1st century A.D.	Cat. no.5 n.8
				Antonine portrait	Cat. no.7 n.4
Parma, Museo Nazionale di Antichita			Chiostro 68	Urania	Cat. no.9 n.20
	early Severan portrait	Cat. no.8 n.7			
			Rome, Museo Torlonia		
Petworth House				Antonine portrait statue as Ceres	Cat. no.6 n.8
	portrait restored by Cavaceppi	Cat. no.10		Antonine portrait	Cat. no.7 n.4
	late Severan portrait	Cat. no.9 n.10			
	Antonine portrait	Cat. no.6 n.6	**Rome, Museo Vaticano**		
			Braccio Nuovo 43	late Severan portrait	Cat. no.9
Pisa, Campo Santo					
inv. 1833	late Severan sarcophagus	Cat. no.9 n.12	**Rome, Museo Vaticano**		
			Cortile Ottagone inv. 1038	Trajanic grave altar	Cat. no.2 n.7
Potsdam, formerly					
	Urania	Cat. no.9 n.19	**Rome, Museo Vaticano**		
			Galleria Lapidaria 31c	early Augustan grave relief	Cat. no.1 n.4
Private Collection, Danish					
	early Severan portrait	Cat. no.8 n.7			

Museum	Description	Reference
Rome, Museo Vaticano		
Museo Chiaramonti		
inv. 500	Antonine grave relief	Cat. no.7 n.4
inv. 546	Antonine portrait	Cat. no.7 n.8
Rome, Museo Vaticano		
Museo Gregoriano Profano Lateranense		
inv. 10528	grave relief of Claudia Semne	Cat. no.3 n.9
Rome, Palazzo dei Conservatori		
inv. 889	Matidia	Cat. no.10 n.1
inv. 1083	Faustina Maior	Cat. no.6 n.6
inv. 2430	Trajanic portrait	Cat. no.2 n.6
Rome, Praetextatcatacombe		
	"Balbinus" sarcophagus	Cat. no.9 n.12
Rome, Villa Albani		
inv. A525	Livia	Cat. no.11 n.2

Museum	Description	Reference
Rome, Villa Borghese		
	statue, copy of cat. no.5	Cat. no.5 n.10
Rome, Villa Doria Pamphilji		
	Antonine portrait	Cat. no.7 n.4
Side, Museum		
inv. 81	statue of Hygieia	Cat. no.9 n.14
Stockholm, Royal Palace		
inv. NM sk 10	Calliope	Cat. no.9
inv. NM sk 4–12	nine muses	Cat. no.9 n.17
inv. NM sk 12	Urania	Cat. no.9 n.19
Tripolis Museum		
	Faustina Maior	Cat. no.7
Wörlitz, Castle		
	Livia	Cat. no.11 n.5
Wörlitz, Castle		
	nine muses	Cat. no.9 n.18

CONCORDANCES

Introduction

The concordance is adapted from a larger database of the collection. This incorporates a fuller record for each item which has details of dimensions, restoration, source, method of acquisition, bibliography and published references. This will be enhanced as catalogue entries for each piece are assembled. The database currently runs on an IBM-compatible microcomputer with a commercial software package called Dbase III+. This allows a sophisticated level of cross-referencing and retrieval by particular categories of information. Full details are available from Liverpool Museum and enquiries are welcomed. This database will be developing over the next few years as the project continues and detailed autopsy of individual pieces produces more definitive information. The present concordance is only intended, therefore, to be an interim publication.

Blundell's Account 1803/10

The number of the piece as it appeared in Blundell's "Account . . ." of 1803 and his "Engravings . . ." of 1810. The concordance is ordered according to this number. At the close of the project, when all cataloguing and re-attribution is complete, the collection will be renumbered strictly according to the original Ince numbering of 1803 and 1809. Future publications in this series will refer to pieces by their Ince reference, rather than to Ashmole or Michaelis.

Identity Number

This field refers to the museum or other number currently used to identify the object. The Ince Collection was given the group number 1959.148 when it entered the museum. This accession number is unique and precedes an individual running number given to each object. For the most part the number given to each piece in 1959 was the number in Ashmole, as Bernard Ashmole had prepared a list and valuation as part of the transfer process. In many cases, though, the reference in Ashmole is only cursory and the real reference is to Michaelis. Many of the objects, however, were still marked in black ink with the original number used at Ince. With a few exceptions, this is the number which appears in Blundell Acc. If it was not clear what the Ashmole or Michaelis number for the piece was, then this original Ince number was used. Items transferred to the Walker Art Gallery since 1959 have been renumbered within the gallery inventory. In this concordance the letters WAG are used to clarify this notation.

When work started in earnest on the collection in 1984 it became clear that there were many pieces which had lost their original documentation or had been wrongly identified. Mistakes were made by Blundell, Michaelis and Ashmole, as well as those who physically marked the objects at Ince. This is hardly surprising in view of the sheer size of the collection and the cursory nature of some of the descriptions; "Head of boy, modern", for example, could apply to several items. The concordance in Ashmole is particularly prone to errors and duplication. In addition therefore to the three numbering systems, labelled in the concordance as Blundell's Account 1803/10, Ashmole 1929 and Michaelis 1882, we have given unidentified pieces numbers commencing at 1000. Many such pieces have been re-attributed during the preparation of this concordance and it is to be hoped that many more will be "found". Inevitably many will have to remain with this new numbering. A number of pieces have been found to have no identifying number at all; often because the piece is a modern restoration which has become separated from its antique host. An added complication is Blundell's admission that not all the fragments in marble and bronze were mentioned in the printed catalogue. For the sake of completeness all the entries in Blundell Acc. have been included; a large number of modern bronzes, casts and curios therefore appear alongside the sculpture. Most of these were ignored by Michaelis and Ashmole.

Description

This section is a simple description of the piece, with a standard format. It is derived from the Museum's existing documentation, which relies heavily on Michaelis and Ashmole, but has been revised for the ash chests and the portraits. Where a specific piece has not been analysed in detail, a more general term has been used. Many sarcophagi, for example, will still be classed as "relief", and no distinction has been attempted between "figure" and "statuette". It is intended that this is merely used as an aid to identification and not as a catalogue entry.

Ashmole 1929

The number of the piece as it appears in Ashmole. There is no entry in this column of the concordance for items not mentioned by Ashmole or marked as "not catalogued" by him. Ashmole did however catalogue a number of items from existing documentation without seeing them at Ince. The symbol "#" is used to denote an item merely listed by Ashmole as adequately catalogued by Michaelis.

Michaelis 1882

The number of the piece as it appears in Michaelis. There is no entry in this column for items not mentioned by Michaelis or marked as "not catalogued" by him. Again there were a number of items catalogued by Michaelis from existing records but not actually seen at Ince.

Current Location

The following terms have been used.

Unknown: Either lost or at present unidentified in current documentation[1].

Ince: Still located at Ince Blundell and not in the possession of the National Museums and Galleries on Merseyside.

Private Coll: Removed from Ince Blundell in 1960 and now in a Private Collection.

Museum: An ancient piece curated by Liverpool Museum, National Museums and Galleries on Merseyside[2].

Gallery: A "modern" piece curated by the Walker Art Gallery, National Museums and Galleries on Merseyside.

Notes

1. A cautious policy has been adopted at this stage in re-identifying pieces. The description in Blundell Acc. is often too vague to allow a definite identification. We prefer to assume that the location is unknown at the moment rather than confuse the issue with mistaken attributions. Each scholar working on the project will gradually eliminate some of the present confusion over the ensuing years.
2. The division between the Museum and Gallery was done in 1960 and then again in the late 1970s. The distinction between ancient and "modern", i.e. 18th-century or even earlier, is straightforward in the majority of cases, but some pieces are the subject of debate. These will be discussed in the catalogue entries proper.

Concordance 1:
Between Blundell's Account 1803/10, Ashmole 1929 and Michaelis 1882, with description and current location

Blundell's Account 1803/10	Identity Number	Description	Ashmole 1929	Michaelis 1882	Current Location
0001	0008	statue, female, draped, "Ince Athena"	0008	0008	Museum
0002	0022	statue, female, draped, Artemis	0022	0022	Museum
0003	0043	statue, male, naked, Theseus	0043	0043	Museum
0004	0002	statue, male, naked, Zeus	0002	0002	Museum
0005	0020	statuette, male, draped, Asclepius	0020	0020	Museum
0006	0048	statue, portrait, male, togate	0048	0048	Museum
0007	0052	statue, female, draped, with head, portrait, Severan	0052	0052	Museum
0008	0009	statue, female, draped, Athena	0009	0009	Museum
0009	0042	statue, female, draped, Phrygia	0042	0042	Museum
0010	0003	statue, draped, female, Demeter	0003	0003	Museum
0011	0054	statue, male, draped, architectural Egyptian	0054	0054	Museum
0012	0013	statue, male, naked, restored as Apollo	0013	0013	Museum
0013	0010	statue, female, draped, Athena	0010	0010	Museum
0014	0031	statue, male, naked, young Dionysus	0031	0031	Museum
0015	0034	statue, female, draped, Maenad or Muse	0034	0034	Museum
0016	(WAG) 8777	head, female, Anchirrhoe, modern, originally restored on ancient statue	0037	0037	Gallery
0016	0037	statue, female, inscribed Anchirrhoe	0037	0038	Museum
0017	0017	statue, female, Psyche by Canova, modern			Private Coll.
0018	0004	statuette, female, draped	0004	0004	Museum
0019	0019	statuette, female, draped, alabaster, modern	0019	0019	Unknown Private Coll.
0020	0024	statuette, female, draped, Egyptian headdress	0024	0024	Museum
0021	(WAG) 10338	statuette, female, draped Muse	0068	0068	Gallery
0022	0006	statuette, boy, draped with corn & flowers	0006	0006	Ince?
0023	0018	statuette, female, draped, muse	0018	0018	Ince?
0024	0049	statuette, portrait, male, semi-draped, ?Antinous	0049	0049	Museum
0025	0025	statue, male, Paris, modern			Private Coll.
0026	0026	statuette, male, Shepherd, modern			Unknown
0027	0055	statuette, female, draped, priestess of Isis	0055	0055	Museum
0028	0040	statuette, female, draped, archaistic "Spes" type	0040	0040	Museum
0029	0021	statuette, male, Asclepius	0021	0021	Museum
0030	0028	statuette, male, wings on helmet, Hermes	0028	0028	Museum
0031	0027	statuette, boy, winged sandals, Hermes	0027	0027	Museum
0032	0026	statuette, boy, naked, Eros	0026	0026	Museum
0033	0045	statuette group of boy (Eros) and swan	0045	0045	Museum
0034	0029	statuette, male, naked, Hermes	0029	0029	Museum
0035	0071	statuette, female, draped, with portrait head	0071	0071	Museum
0036	0046	statuette, portrait, boy, draped holding bird	0046	0046	Museum
0037	0023	statuette, female, restored as Artemis	0023	0023	Museum
0038	0033	statuette, female, draped, Nemesis	0033	0033	Museum
0039	0005	statuette, male, semi-naked, Silvanus	0005	0005	Museum
0040	0040	statuette, boy with bird, Antonio D'Este, modern			Private Coll.

Blundell's Account 1803/10	Identity Number	Description	Ashmole 1929	Michaelis 1882	Current Location
0041	0041	statuette, girl with nest, Antonio D'Este, modern			Private Coll.
0042	0042	statuette, female, Venus Callipeges, modern			Private Coll.
0043	0043	statuette, male, Apollo, modern			Private Coll.
0044	0044	statuette, female, Isis, modern			Private Coll.
0045	0045	statue, male, Pythagoras, copy			Unknown
0046	0046	statuette, female, Ceres, "copy from original at Rome" – Acc.			Private Coll.
0047	0047	statuette, Dying Gaul, Antonio D'Este, modern			Private Coll.
0048	0048	statuette, female, modern			Unknown
0049	0044	statuette, male, draped, seated, Epicurus	0044	0044	Museum
0050	0072	statuette, male, draped seated, with portrait head, modern	0072	0072	Museum
0051	0038	statuette, male, draped, Serapis, enthroned	0038	0038	Museum
0052	0016	statuette, male, semi-draped, seated, restored as ?Apollo	0016	0016	Museum
0053	0047	statuette, male, draped, seated fisherman	0047	0047	Ince
0054	0007	statuette, portrait, female, draped, seated on throne as Fortuna	0007	0007	Museum
0055	0039	statuette, Serapis	0039	0039	Museum
0056	0001	statuette, seated on throne, female, Cybele	0001	0001	Museum
0057	0035	statuette group, Satyr boy with goat	0035	0035	Gallery
0058	0056	statuette, female, Egyptian (not illus. Ashmole)	0056	0056	Museum
0059	0053	statuette, female, Egyptian, (not illus. Ashmole)	0053	0053	Museum
0060	0060	figure, male, Mercury, bronze, "the work of John de Bologna" – Acc.			Private Coll.
0061	0073	statuette, male, naked Dionysus, bronze	0073	0073	Private Coll.
0062	0062	figure, female, Venus, bronze, "a good cinquecento piece" – Acc.			Private Coll.
0063	0063	figure, male, Adonis, bronze, "school of Michael Angelo" – Acc.			Private Coll.
0064	0189a	bust, female, portrait, Faustina Minor, bronze, modern	0189a		Private Coll.
0066	0066	caryatid, terracotta, "modelled by Cavaceppi" – Acc.			Private Coll.
0067		figure, captive slave, terracotta, "bought of sculptor Pacetti" – Acc.			Unknown
0068		figure, captive slave, terracotta, "bought of sculptor Pacetti" – Acc.			Unknown
0069	(WAG) 6580	statuette, male, seated, Posidippus, terracotta	0069		Gallery
0070	(WAG) 6581	statuette, male, seated, Menander, terracotta	0070		Gallery
0071	0071	figure, male, "modelled from statue of Zeno in Capitol at Rome" – Acc.			Private Coll.
0072	0083d	statuette, boy, seated with wings, Eros	0083d		Private Coll.
0073	0032	statue, male, naked, young Dionysus	0032	0032	Museum
0074	0017	statuette, female, draped, possibly Aphrodite	0017	0017	Museum
0075	0030	statue group of Satyr and Hermaphrodite	0030	0030	Museum
0076	0014	statue, male, naked, Apollo	0014	0014	Museum
0077	0077	statue, animal, hawk, Egyptian, modern (not illus. Ashmole)	0060	0060	Private Coll.
0078	0057	statue, animal, baboon	0057	0057	Museum
0079	0075	statue, animal, hawk, Egyptian	0075	0075	Museum
0080	0076	(=0041 Ashmole)	0076=0041		
0080?	0041	statuette, female, draped, archaistic	0041	0076?	Museum
0081	0081	Copy of Ince Theseus			Private Coll.

Blundell's Account 1803/10	Identity Number	Description	Ashmole 1929	Michaelis 1882	Current Location
0082	(WAG) 6895	statuette, male, Trajan, terracotta, modern			Gallery
0083	0083	Madonna in terracotta by Canova			Private Coll.
0084	0292	relief, Silvanus, (not illus. Ash.)	0292	0292	Ince
0085	0077	statue, animal, tigress	0077	0077	Museum
0086	0059	statue, animal, cock	0059	0059	Ince
0087	0078	statue, animal, hare, running	0078	0078	Museum
0088	0079	statue, animal, lioness, winged	0079	0079	Museum
0089	0080	(=238a Ashmole)	0080 =0238a	0080	
0089	0238a	relief, figure, male, general with portrait	0238a	0080	Museum
0090	0084	bust, male, portrait, Hadrian	0084	0084	Museum
0091	0085	bust, male, portrait, Septimius Severus	0085	0085	Museum
0092	(WAG) 9112	bust, male, portrait, Otho	0086	0086	Gallery
0093	0087	bust, male, portrait, Hadrianic	0087	0087	Museum
0094	0088	bust, male, portrait, colossal, Augustus	0088	0088	Museum
0095?	0145	bust, male, Apollo	0145	0145	Museum
0096	(WAG)10340	bust, female, Fourth century style, ?modern	0146	0146	Gallery
0097	0089	head, bust, male, portrait, colossal, Augustus	0089	0089	Museum
0097	0147	(=89 Ashmole)	0147=0089		
0098	0139	bust, male, portrait, colossal, Vespasian, modern	0139	0139	Museum
0099	(WAG) 6530	head, male, colossal, Jupiter, modern, (by Angelini)			Gallery
0100	(WAG) 6538	bust, male, portrait, Lucius Verus, modern, (by Albacini)			Gallery
0101	(WAG) 6537	bust, female, colossal, Athena, modern (by Albacini)			Gallery
0102	(WAG) 6900	bust, male, Bacchus, modern, (by Albacini)			Gallery
0103	(WAG) 9106	bust, male, Alexander the Great, modern, (by Albacini)			Gallery
0104=0097	0089	Ince 97 & 104 are busts of Augustus but Ashmole implies they are one piece	0089	0147=0089	
0105	0090	bust, male, Hadrianic	0090	0090	Museum
0106	0148	bust, male, portrait	0148	0148	Museum
0107	0093	bust, female, portrait, Severan	0093	0093	Museum
0108	0091	bust, portrait, female, Antonine	0091	0091	Museum
0109	0095	bust, female	0095	0095	Museum
0110	0096	herm, Young Dionysus	0096	0096	Museum
0111	0111	bust, male, herm, companion to Ince 112	0149	0149	Museum
0112	0150	herm, male, portrait, inscribed M Cato	0150	0150	Museum
0113	0151	bust, male, Serapis	0151	0151	Museum
0114	0102	bust, female, with Egyptian-style coiffure	0102	0102	Museum
0115	(WAG) 10333	bust, male, portrait, Republican	0101	0101	Gallery
0116	0152	bust, male, athlete, Greek	0152	0152	Museum
0117	0099	bust, male, portrait, Republican	0099	0099	Museum
0118	0100	bust, male, portrait, Republican	0100	0100	Museum
0119	0153	bust, male, athlete	0153	0153	Museum
0120	0104	bust, female, portrait, Traianic	0104	0104	Museum
0121	(WAG) 9109	head, male, modern			Gallery
0122	(WAG) 6536	bust, male, portrait, "Julius Caesar", modern, porphory	0144	0144	Gallery
0123	0154	bust, male, portrait, Roman prince	0154	0154	Museum
0124	0124	centaur, bronze, "cast from figure in Capitol" – Acc.			Private Coll.
0125	0125	centaur, bronze, "cast from figure in Capitol" – Acc.			Private Coll.
0126	0097	herm, Heracles	0097	0097	Museum
0127	0155	bust, boy, portrait, Iulio-Claudian	0155	0155	Museum
0128	0117	head, male, Hellenistic youth	0117	0117	Museum

Blundell's Account 1803/10	Identity Number	Description	Ashmole 1929	Michaelis 1882	Current Location
0129	0107	bust, female	0107	0107	Museum
0130	0094	bust, female, Omphale	0094	0094	Museum
0131	0156	bust, male, Satyr	0156	0156	Museum
0132	0109	bust, female, portrait, Faustina Maior	0109	0109	Museum
0133	0157	bust, boy, portrait as Mercury, Traianic	0157	0157	Museum
0134		"Mary Queen of Scots in cannel . . . work of a Mr. Town of Wigan" – Acc.			Unknown
0135		"Henry VIII, cannel . . . work of Mr. Town of Wigan" – Acc.			Unknown
0136	(WAG) 9113	bust, male, "Nero"	0158	0158	Gallery
0137	0159	bust, male, small, Serapis, alabaster	0159	0159	Private Coll.
0138		Egyptian idol			Unknown
0139		"A bifrons . . . faces of a male and female bacchus bt from Cavaceppi" – Acc.			Ince
0140	0161	bust, male, Satyr, rosso Antico	0161	0161	Private Coll.
0141	0162	bust, male, Eleusinian Mystes	0162	0162	Museum
0142	(WAG) 10344	head and fragment of shoulders, male, Hercules, ?modern	0163	0163	Gallery
0143	0113	bust, boy, wearing cowl	0113	0113	Museum
0144	(WAG) 9115	bust, male, portrait, Vitellius, modern	0116	0116	Gallery
0145	0118	bust, female	0118	0118	Museum
0146	0111	double herm, males	0111	0111	Museum
0147	0120	bust, female, Aphrodite	0120	0120	Museum
0148	0164	bust, male, portrait, Socrates	0164	0164	Museum
0149	0122	bust, male, portrait, Antonine	0122	0122	Museum
0150	0108	head, ?male/female, Fourth century BC style	0108	0108	Museum
0151	(WAG) 10341	bust, male, portrait, Homer, small	0115	0115	Gallery
0152	0106	bust, male, Hermes	0106	0106	Museum
0153	0165	herm, male, Dionysus/Hermes, rosso antico	0165	0165	Private Coll.
0154	0166	herm, male, terminal, Dionysus/Hermes, giallo-antico	0166	0166	Museum
0155	0167	bust, female, portrait, ?modern	0167	0167	Museum
0156	0114	bust, boy, with bearskin as Heracles	0114	0114	Museum
0157	0123	bust, male, water-god, colossal	0123	0123	Museum
0158	(WAG) 10335	head, male, portrait, Claudius, modern	0124	0124	Gallery
0159	0125	head, male, portrait, Domitianic	0125	0125	Museum
0160	(WAG) 6629	bust, torso, female, pseudo-Artemis	0081	0081	Gallery
0160	0206	herms, (see Ashmole 160)	0206	0227	Ince
0161		cast, of Medusa in "Rondonini palace at Rome" – Acc.			Unknown
0162		cast, plaster, Isis, "from that admired head in the Vatican" – Acc.			Unknown
0163	0126	herm, male, Zeus Ammon	0126	0126	Museum
0164	(WAG) 9110	bust, female, portrait, Livia, modern	0143	0143	Gallery
0165	0092	bust, male, Silenus	0092	0092	Museum
0166	0168	bust, male, portrait, Homer, ?modern	0168	0168	Gallery
0167	0169	bust, male, Dionysus, (not illus. Ashmole), bronze, modern	0169	0169	Private Coll.
0168	0170	head, male, boy, (not illus. Ashmole), bronze	0170	0170	Private Coll.
0169	(WAG) 6534	head, male, youth, bronze, modern	0171	0171	Gallery
0169	0213	(=0171 Ashmole)	0213=0171		
0170	0172	head, male, portrait, Traianic	0172	0172	Museum
0171	0105	bust, male, youth	0105	0105	Museum
0172	0121	bust, male, water god	0121	0121	Museum

Blundell's Account 1803/10	Identity Number	Description	Ashmole 1929	Michaelis 1882	Current Location
0173	0173	head, female, Aphrodite	0173	0173	Museum
0174	0174	bust, male, portrait, Domitianic	0174	0174	Museum
0175	0203	head, youth, with cap	0203		Museum
0176	0175	bust, female, Greek type	0175	0175	Museum
0177	0103	(=0176 Ashmole)	0103=0176		
0177	0176	bust, male, portrait, Menander	0176	0176	Museum
0180	0178	bust, male, portrait, Hellenistic ruler	0178	0178	Museum
0181		head, "copy of head of Mercury from Lansdowne by Antonio D'este" – Acc.			Unknown
0182	0133	mask, female	0133	0133	Ince
0183	(WAG) 6901	bust, male, modern			Gallery
0184	(WAG) 10347	bust, Apollo or Aphrodite	0209		Gallery
0185	(WAG) 9108	bust, female, Venus, modern			Gallery
0186	0222	relief, funerary, inscribed	0222	0222	Ince
0187	0179	bust, male, Apollo, of Cassel type	0179	0179	Museum
0188	0180	bust, female, veiled	0180	0180	Museum
0189	0127	herm, male, Priapus	0127	0127	Museum
0190	0129	head, female, East Greek style	0129	0129	Museum
0191	0061	fragment, Egyptian figure	0061	0061	Museum
0192	0110	bust, male, portrait, Menander	0110	0110	Museum
0193	0181	head, female, miniature, Aphrodite, green basalt, modern	0181	0181	Private Coll.
0194/5	0182	bust, boy, portrait, Traianic	0182	0182	Museum
0195	0205	see 0195	0205	0205	
0195	0205a	see 0195	0205a		
0195/4	0183	bust, boy, portrait, Trajanic	0183	0183	Museum
0196	0184	bust, male, Satyr	0184	0184	Ince
0197	0185	bust, male, satyr	0185	0185	Ince
0198	0186	bust, male, portrait, Antonine	0186	0186	Museum
0199	0187	bust, male, portrait, Early Empire	0187	0187	Museum
0200	0188	bust, female, Aphrodite	0188	0188	Museum
0201	(WAG) 6628	bust, female, portrait, Faustina Minor, modern	0189	0189	Gallery
0202	0190	bust, hermaphodite	0190	0190	Museum
0203	0191	bust, portrait, modern (not illus. Ashmole)	0191	0191	Unknown
0204	0192	head with shoulders, male, of Polycleitan statue	0192	0192	Museum
0205	0193	bust, male, Eros	0193	0193	Museum
0206	0194	bust, female, nymph	0194	0194	Museum
0207	0219	mask, tragic, from sarcophagus	0219	0219	Museum
0208	0219a	mask, tragic, from sarcophagus	0219a	0219a	Museum
0209	0134	mask, male, tragic	0134	0134	Ince
0210	0134a	mask, tragic, (not illus. Ashmole)	0134a	0134a	Unknown
0211	0136	mask, male, comic	0136	0136	Ince
0212	0130	mask, female	0130	0130	Ince
0213	0131	mask, female	0131	0131	Ince
0214	0195	reliefs, six lion heads	0195	0195	Ince/Museum
0215	0217c	(=0196 Ashmole)	0217c=0196		
0215	0196	bust, male, portrait, Severus Alexander	0196	0196	Museum
0216	0197	bust, male, ?Satyr	0197	0197	Museum
0217	0198	bust, male, with cap, ?Dioscurus	0198	0198	Museum
0218	0199	bust, male, with cap, ?Dioscurus	0199	0199	Museum
0219	0200	bust, male, Satyr	0200	0200	Museum
0220	0201	bust, male, portrait, Hadrianic	0201	0201	Museum
0221	0202	bust, boy, portrait, third century A.D.	0202	0202	Museum
0223	0204	bust, female, Athena	0204	0204	Museum

Blundell's Account 1803/10	Identity Number	Description	Ashmole 1929	Michaelis 1882	Current Location
0224	(WAG) 6905	medallion, with head of woman in high relief			Gallery
0225		lion heads, two, see 214 (Ash. 195)	0195		
0226	0112	double herm, male/female, portraits	0112	0112	Museum
0227		head from herm, see 339			
0228	(WAG) 10348	bust, female, with double veil	0207	0207	Gallery
0229	0138	head, male, bearded, ?modern	0138	0138	Unknown
0230	0208	herm, male, portrait, Socrates	0208	0208	Museum
0231		head, female, "suffered so much from injuries of time & accidents" – Acc.			Unknown
0232	0210	bust, male, portrait, Late Trajanic	0210	0210	Museum
0233	0211	bust, female, Athena	0211	0211	Unknown
0234	0212	head, boy, bronze, modern	0212	0212	Private Coll.
0235		head in bronze, "bought in a lot in order to get at other marbles" – Acc.			Unknown
0236		relief "Edward & Eleanora. Modelled at Rome by Deare of Liverpool" – Acc.			Ince
0237	0241	candelabrum(?)	0241	0241	Museum
0238	0243	lid of sarcophagus, front, Dionysiac scene	0243	0243	Museum
0239	0246	relief, back of sarcophagus, "Hippolytus"	0246	0246	Museum
0240	0223	relief, front of sarcophagus	0223	0223	Museum
0241	0247	sarcophagus, front of, Cupids' chariot race	0247	0247	Ince
0242	0248	relief, from sarcophagus, birth of Dionysus	0248	0248	Museum
0243	0249	relief, from sarcophagus, triumph of Dionysus	0249	0249	Museum
0244	0251	relief, Artemis, archaistic	0251	0251	Museum
0245	0250	relief, Victory sacrificing before trophy	0250	0250	Museum
0246	0244	lid of sarcophagus, hunting scene	0244	0244	Museum
0247	0253	lid of sarcophagus, Oceanus mask and sea creatures	0253	0253	Museum
0248	(WAG) 6902	relief, children playing with balls, modern			Gallery
0249	0224	relief, front of sarcophagus, winged boys and vase	0224	0224	Unknown
0250	0256	sarcophagus, end of, cupid on horse, (not illus. Ash), Eng. 95,2	0256	0256	Museum
0251	0257	sarcophagus, end of, cupid on horse, (not illus. Ash.), Eng. 95,3	0257	0257	Unknown
0252	0410	Mosaic, Thetis before Zeus	0410	0410	Private Coll.
0253	0258	relief, convex, male, seated on rock, Poseidon	0258	0258	Museum
0254	0260	relief, funerary, 2 figures in front of pedestal, East Greek	0260	0260	Museum
0255	0263	sarcophagus, end of, with Ash. 262, Phrygian blowing pipes	0263	0263	Museum
0256	0262	sarcophagus, end of, with Ash. 263, Aphrodite and Paris	0262	0262	Museum
0257	0265	sarcophagus, end of, wind god, (poss. end Ash. 221)	0265	0265	Museum
0258	0264	sarcophagus, end of, wind god, (poss. end Ash. 221)	0264	0264	Museum
0259		slab of Florentine marble, "all natural without any art used in it" – Acc.			Unknown
0260	0276	sarcophagus ends(2), griffins, (not illus. Ashmole)	0276	0276	Ince
0261		plaster model, "Bacchanalian group" – Acc.			Unknown
0262		model in plaster, "Orpheus with his music" – Acc.			Unknown
0263	0259	relief, male seated, Zeus, archaic	0259	0259	Museum
0264	0267	relief, centaur and panther	0267	0267	Museum
0265	0269a	(=0270 Ashmole)	0269a=0270		

Blundell's Account 1803/10	Identity Number	Description	Ashmole 1929	Michaelis 1882	Current Location
0266	0261	relief, funerary, banquet scene, Greek	0261	0261	Museum
0267	0267	relief, winged victory			Museum
0268		Pope Sixtus Quintus, "Negroni Collection" – Acc.			Ince
0269	0372	relief, lion's head cf. 269,195	0372 =0195	0372	Museum
0270	(WAG) 6527	vase, "entirely reworked" – Ashmole (by Piranesi), Bacchic figures	0404	0404	Gallery
0271		architectural fragments, "Ancient modillions" – Acc.			Unknown
0272	0271	relief, pendant, Dioscuri, (with Ash. 272)	0271	0271	Ince
0273	0272	relief, pendant, Dioscuri, (with Ash. 271)	0272	0272	Ince
0274	0373	relief, charioteer, (not illus. Ashmole), ?modern	0373	0373	Ince
0275	0373a	relief, lion & bull, ?modern	0373a		Ince
0275	0374	sarcophagus, end of, lion	0374	0374	Museum
0276	0375	sarcophagus, front of, victories holding portrait of boy, (not illus. Ash.)	0375	0375	Ince
0277	0275	sarcophagus, front of, deeds of Pan	0275	0275	Ince
0278	0269	mask, wood/water god above festoon	0269	0269	Museum
0279	0220	relief, head of Medusa above festoon	0220	0220	Ince
0279	0270	mask, Medusa above festoon	0270	0269a	Museum
0280	0277	relief, sacrifice of bull	0277	0277	Unknown
0281	0376	sarcophagus, fragment of, female on sea monster	0376	0376	Ince
0282	0377	sarcophagus, front of, 3 cupids	0377	0377	Ince
0283	0255	sarcophagus, front of, Cupids chariot-racing	0255	0255	Museum
0284	0278	sarcophagus, front of, boys, eagle holding garlands	0278	0278	Ince
0285	0279	sarcophagus, fragment of, Achilles in Chariot	0279	0279	Ince
0286	0266	sarcophagus, front of, Dionysiac scene	0266	0266	Ince
0287	0282	relief, punishment of Prometheus	0282	0282	Museum
0288	0378	sarcophagus, front of, portrait and figures	0378	0378	Museum
0289	0242	relief, Medusa mask above festoon, (not illus. Ashmole), Eng. 88,3	0242	0242	Ince
0290	0379	relief, head, Medusa	0379	0379	Ince
0291	0284	relief, slab, decorative, garland and bucrania, see 292, (not illus. Ash.)	0284	0284	Ince
0292	0283	relief, slab, decorative, garland and bucrania, see 291, (not illus. Ash.)	0283	0283	Ince
0293		hand, "though modern, much admired for its fleshiness" – Acc.			Unknown
0294	0380	relief, mask, satyr, (not illus. Ashmole), ?modern	0380	0380	Unknown
0295		fragment, head of hair			Unknown
0296	0381	relief, eagle, (not illus. Ashmole)	0381	0381	Ince
0297	0382	relief, sunmask, modern, (not illus. Ashmole)	0382	0382	Ince
0298		fragment, ?handle of vase, "on it is carved a Medusa's face" – Acc.			Unknown
0299	1030	fragment, relief, egg and dart pattern			Museum
0300	0135	mask, female, Medusa	0135	0135	Ince
0300	0383	(=0135 Ashmole)	0383=0135		
0301	(WAG) 10346	relief, boar with two dogs, ?modern	0384	0384	Gallery
0302	0385	head, porphory, in pointed helmet	0385	0385	Museum
0303		portrait of Sappho, "Medallion in alto-relievo" – Acc.			Unknown
0304		fragment, "back part of ancient head, hair well treated" – Acc.			Unknown
0305	0132	mask, water god	0132	0132	Unknown
0305	0387	relief, mask of Pan	0387	0387	Ince

Blundell's Account 1803/10	Identity Number	Description	Ashmole 1929	Michaelis 1882	Current Location
0306	0388	relief, Dionysiac, mask, (?)modern, (not illus. Ashmole)	0388	0388	Ince
0307	0399	table support, lion, (not illus. Ashmole)	0399	0399	Museum
0308	0400	table support, griffin, (not illus. Ashmole)	0400	0400	Museum
0309		bronze pedestal, "Cinquecento . . . it supports a grey granite table" – Acc.			Unknown
0310	0389	reliefs, heads, two, ?from sarcophagus	0389	0389	Museum
0311	0254	relief, frieze, marine procession	0254	0254	Museum
0312	0285	relief, slab, decorated with acanthus (not illus. Ashmole)	0285	0285	Ince
0313	0288	relief, Bacchic scene, ?modern	0288	0288	Ince
0314	0290	relief, Orpheus among the Satyrs	0290	0290	Museum
0315		relief, "some ancient architecture, very singular and irregular" – Acc.			Unknown
0316	0293	relief, ploughman, (not illus. Ashmole)	0293	0293	Ince
0316	0294	relief, architectural design, (not illus. Ashmole)	0294	0294	Ince
0317	0390	relief, masks, see index Ashmole	0390	0390	Unknown
0318	0281	sarcophagus, fragment of, rape of Persephone	0281	0281	Museum
0319	0308	relief, slab, satyr dancing	0308	0308	Museum
0320	0295	relief, Egyptian style	0295	0295	Museum
0321	0309	relief, Satyr before Herm	0309	0309	Museum
0322	0289	relief, archaistic, Hygeia offering	0289	0289	Museum
0323	0296	relief, Cupids gathering quinces	0296	0296	Museum
0324	0268	sarcophagus, fragment of, lion hunt	0268	0268	Museum
0325	0297	relief, wild boar, (not illus. Ashmole)	0297	0297	Unknown
0326	0298	relief, scene after vintage	0298	0298	Museum
0327	0286	relief, decorated with acanthus, 2 fragments	0286	0286	Museum
0328	0287	sarcophagus, end of, herdsman	0287	0287	Ince
0329	0299	relief, slab, decorated, (not illus Ashmole), ?modern	0299	0299	Ince
0330	0300	relief, slab, decorated, (not illus Ashmole), ?modern	0300	0300	Ince
0331	0227	relief, funerary, 4 portraits, 2 men, 2 women	0227	0227	Ince
0332	0225	relief, lid of child's sarcophagus	0225	0225	Museum
0333	0280	sarcophagus, front of, Amazonimachy	0280	0280	Ince
0334	0301	fragment, Medusa head, from corner of sarcophagus lid	0301	0301	Museum
0335	0391	sarcophagus, end of, herdsman and herd	0391	0391	Ince
0336	0128	sundial with portrait bust	0128	0128	Museum
0338	0062	cista mystica (part of 0435 – Michaelis)	0062	0062	Museum
0339/0227	0160	herms, 2 male, 2 female, ?modern	0160	0160/0206	Ince
0340	0392	oscillum, with three masks	0392	0392	Museum
0341	0229	sarcophagus, oval, marriage ceremony	0229	0229	Museum (loan 1987–)
0342	0232	sarcophagus lid, oval, actors and symbols of drama	0232	0232	Museum
0343	0233	sarcophagus with lid, portrait of a boy, seasons and dioscuri	0233	0233	Museum
0344	0313	Ash chest of Lepidia Privata & M. Lepidius Epigonus, C.I.L. VI 21197	0313#	0313	Museum
0345	0273	sarcophagus, end of, lion and roe	0273	0273	Museum
0346	0360(M)	Ash chest of M. Claudius Paetus, C.I.L. VI 15181	0360#	0360	Museum
0347	0361	Ash chest of Aninia, Asterius & C. Iulius Speratus	0361#	0361	Museum
0348	0354(M)	Ash Chest of L. Antonius Felix, C.I.L. VI 11990	0354#	0354	Museum
0349	0355(M)	Ash chest of L. Manlius Philargyrus & Larcia Rufina, C.I.L. VI 21949	0355	0355	Museum

Blundell's Account 1803/10	Identity Number	Description	Ashmole 1929	Michaelis 1882	Current Location
0350	0356(M)	Ash chest of M. Clodius Castor, C.I.L. VI 15712	0356	0356	Museum
0351	0315	Ash chest of Euphrosyne	0315	0315	Museum
0352	0317	Ash chest of Q. Curiatius Zosimus, C.I.L. VI 16625	0317	0317	Museum
0353	0321(M)	Ash chest of Numisia Primagenia, C.I.L. VI 23134	0321	0321	Museum
0354	0236(M)	Ash chest of Claudius Rufus, C.I.L. VI 15245	0236	0236	Museum
0355	0234(M)	Ash chest of Pholoe, C.I.L. VI 24166	0234	0234	Museum
0356	0326(M)	Ash chest without inscription, birds over door, Engr. 134,4	0326	0326	Museum
0357	0327(M)	Ash chest of Cornelia Staphyle, C.I.L. VI 16458, inscr. probably copied	0327	0327	Museum
0358	0312(M)	Ash chest of C. Iulius Hirmaiscus, C.I.L. VI 20052	0312	0312	Museum
0359	0331	Ash chest of Etrilia Danae, by P. Etrilius Abascantus, C.I.L. VI 17290	0331	0331	Museum
0360	0335	Ash chest of C. Minicius Gelasinus, C.I.L. VI 22524	0335	0335	Museum
0361	0314(M)	Ash chest of Ellis Rufus, Engr. 130,4	0314	0314	Museum
0362	0357(M)	Ash Chest of Saburius Ligus, C.I.L. VI 2589	0357	0357	Museum
0363	0336	Ash chest of C. Ian. (or Pan?.) Carpis & Iustus, C.I.L. VI 13674	0336	0336	Unknown
0364	0333(M)	Ash chest of Rutilia Romana, C.I.L. VI 25679, probably copied	0333	0333	Museum
0365	0231	Ash chest of Sestilia Secunda, C.I.L. VI 26460	0231	0231	Ince
0366	0334	Ash chest of Juliae Meroe, C.I.L. VI 20567	0334	0334	Ince
0367	0341	Ash chest of Prisca, C.I.L. VI 25049	0341	0341	Ince
0368	0311	Ash chest of T. Camdenus Eutuchus, C.I.L. VI 17467	0311	0311	Ince
0369	0332	Ash chest of Flavia Nysa, C.I.L. VI 17467	0332	0332	Ince
0370	0330(M)	Ash chest of L. Cornelius Iason, C.I.L. VI 16242	0330	0330	Ince
0371	0323	Ash chest of T. Flavius Zmaragdus, C.I.L. VI 18257	0323	0323	Ince
0372	0230	Ash chest of Acellius, Eng. 83,1	0230	0230	Ince
0373	0324	Ash chest of Cn. Pompeius Iustus, C.I.L. VI 24476	0324	0324	Ince
0374	0362(M)	Ash chest of Festiva & Flavia Onesime, C.I.L. VI 17895b	0362	0362	Museum
0375	0352(M)	Ash chest of Severina Procilla, Engr. 143,3/4	0352	0352	Museum
0376	0240	Ash chest of Claudia Queita & Claudius Plolus, C.I.L. VI 15573	0240	0240	Museum
0377	0363(M)	sarcophagus, child, inscr. Oppiae Thisbe	0363	0363	Museum
0378	0339	Ash chest of Hermes (dedicated by A. Plautius Gallus), C.I.L. VI 24271	0339	0339	Museum
0379	0337(M)	Round ash chest of C. Iulius Iulianus	0337	0337	Museum
0380	0348(M)	Ash chest of M. Ulpius Eutyches, C.I.L. VI 29187	0348	0348	Museum
0381	0325	Ash chest of T. Flavius Eutyches, C.I.L. VI 18059	0325	0325	Museum
0382	0342(M)	Round ash chest of Antonia Gemella, C.I.L. VI 12048	0342	0342	Museum
0383	0329(M)	Ash chest of Q. Milasius Bassus, C.I.L. VI 2652	0329	0329	Museum
0384	0345(M)	Ash chest of Ti. Claudius Onesimus, C.I.L. VI 15176	0345	0345	Museum
0385	0320	Ash chest of Q. Laflius Primigenius, C.I.L. VI 21027	0320	0320	Museum
0386	0347(M)	Ash chest of Aurelius Ingenuus (ded. by Aurelia Hermione), C.I.L. VI 13332	0347	0347	Museum
0387	0351	urn, cinerary, round, decorated, Engr. 142,3	0351	0351	Unknown
0388	0349(M)	vase-shaped urn of Hylas, C.I.L. VI 19609, probably copied	0349	0349	Museum
0389	0346(M)	Ash chest of Calidia Ursilia and Telesphorus Primitivus, C.I.L. VI 26460	0346	0346	Museum

Blundell's Account 1803/10	Identity Number	Description	Ashmole 1929	Michaelis 1882	Current Location
0390	0350(M)	Ash chest of M. Rufrius Phlapfiphus, C.I.L. VI 25579, probably copied	0350	0350	Museum
0391	0343	Ash chest of Rubria Prima, C.I.L. VI 25548, probably copied	0343	0343	Museum
0392	0322(M)	Ash chest of Publius Severianus, Engr. 133,4-6	0322	0322	Museum
0393	0318	Ash chest of M. Burrius Felix, C.I.L. VI 13663	0318	0318	Museum
0394	0316	Ash chest of the Peducaei, C.I.L. VI 23896	0316	0316	Museum
0395	0358	Ash chest of M. Terentius Restitus & Crocale, C.I.L. VI 27208	0358	0358	Ince
0396	0319(M)	Ash chest of Liviae, C.I.L. VI 21416	0319	0319	Museum
0397	0235	Ash chest of Lappia Prima, C.I.L. VI 21093	0235	0235	Museum
0398	0328(M)	Ash chest of Fulvanus, Engr. 135,2	0328	0328	Museum
0399	0344	Ash chest of "Q.C.P.F.", Engr. 140,2	0344	0344	Museum
0400	0405	urn, glass, (not illus. Ashmole)	0405	0405	Unknown
0401	0340	Cippus of T. Flavius Eutactus, C.I.L. VI 18056	0340	0340	Museum
0402	0302	Cippus of Passienia Gemella, C.I.L. VI 23848	0302	0302	Museum
0403	0364	relief, funerary, inscr. Mallia Mifprofula	0364	0364	Ince
0404	0404	lid of sarcophagus, seasons, AureliI Aufidi, (not illus. Ash.), Eng. 89,3	0245	0245	Museum
0405	0365(M)	relief, inscr. Ti Claudius Rufus	0365	0365	Museum
0406	0366	relief, inscription, Greek	0366	0366	Museum
0407	0237	Gravestone of Iunia Marcella, C.I.L. VI 20894	0237	0237	Museum
0408	0408	Gravestone of T. Aurelius Mansuetinus, C.I.L. VI 3211	0238	0238	Museum
0409	0239	Gravestone of Valeria Prisca, C.I.L. VI 28253	0239	0239	Museum
0410	(WAG) 10345	bust, male, portrait, inscribed Quintus Aristaeus, Traianic	0214	0214	Gallery
0411	0226	relief, funerary, inscribed, of freedmen	0226	0226	Ince
0412	0338	Ash chest of L. Iulius Bassus, Engr. 138,3	0338	0338	Unknown
0413	0367	sarcophagus, front of, inscr. Q.Quintio Eutycheii, (not illus. Ash.)	0367	0367	Museum
0414	0368(M)	slab, in 2 fragments, inscr. Aur Iobinus etc.	0368	0368	Museum
0415	0369	slab, inscr. Verriae Nicopolini	0369	0369	Unknown
0416	0359(M)	slab, inscr. Atiliae Phlegusae	0359	0359	Museum
0417	0370	slab, fragment, inscr. Ulpiae Sabinae	0370	0370	Museum
0418?	0406	urn, glass, (not illus. Ashmole)	0406	0406	Unknown
0419		urn in terracotta, "Found in ruins of Caracalla's baths" – Acc.			Unknown
0420	0420	plinth, orb, hand (missing)			Gallery
0421	0083e	torso, male, naked, Herakles	0083e		unknown
0422	(WAG) 10342	female hand, with supporting column and base, modern			Gallery
0423		antique foot, "belonged to cardinal Alexander Albani" – Acc.			Private Coll.
0424		bronze hand, "not without its merit" – Acc.			Private Coll.
0425		porphory fragment, "uncertain curious draped fragment" – Acc.			Unknown
0426	0083h	leg, right, with tree trunk	0083h		Museum
0427	0427	thigh, fragment, with tree trunk			Museum
0428		hand, holding grapes, "purchased by Mr. Thorpe" – Acc.			Unknown
0429	1014	hand, holding rod, consular ring on finger			Museum
0430	0430	statue, Egyptian, lower half			Museum

Blundell's Account 1803/10	Identity Number	Description	Ashmole 1929	Michaelis 1882	Current Location
0431	0083g	knee, colossal, fragment	0083g		Museum
0432	0083b	torso, male, naked, Pan	0083b		Museum
0433	0083a	torso, male, naked, Pan	0083a		Museum
0434	0083f	torso, male, boy, bronze	0083f		Museum
0435		two feet, base of statue, part of Ince 338			Unknown
0436		two antique feet, "a present from Signior Angelini" – Acc.			Unknown
0437		two antique legs, "much admired for their muscular strength" – Acc.			Unknown
0438	1035	two fragments of heads, "one known by the eye . . . Commodus" – Acc.			Museum (One only)
0439		two female arms, "one remarkable for having on it a bracelet" – Acc.			Unknown
0440	0402	statue base, helmet, stool and altar on plinth	0402	0402	Museum
0441		fragment in porphory, "the neck of a colossal statue" – Acc.			Unknown
0442	0403	armour, greave, fragment, boot, (not illus. Ashmole)	0403	0403	Museum
0443		hand and arm, "model in plaster said to be antique" – Acc.			Unknown
0444		horse, bronze, Bologna-Sussini workshop, modern			Private Coll.
0445		arm, "certainly belonged to some celebrated statue" – Acc.			Unknown
0446		fragment of vase, "on it is a head of Jupiter Ammon" – Acc.			Unknown
0447		small head of Jupiter, "bought by Mr. Thorpe" – Acc.			Unknown
0448	0411	mosaic, six panels, (not illus. Ashmole)	0411	0411	Ince
0449		pillars, two fluted alabaster			Unknown
0450		pillars, two cipollini			Unknown
0451		pillar, "Porta Santa" – Acc.			Unknown
0452		pillar, brescia, "bought from Albacini" – Acc.			Unknown
0453		pillar, "Porta Santa Rubra, bought from Albacini" – Acc.			Unknown
0454		pillar, red granite, "Bought from Albacini" – Acc.			Unknown
0455		pillar, ancient, "ornamented all over with a kind of foliage" – Acc.			Unknown
0456		pillar, same as 455			Unknown
0457		two pillars in wood, "belonged to Sir Gregory Page" – Acc.			Unknown
0458		two small alabaster pillars "Bought with 449" – Acc.			Unknown
0459		two small alabaster pillars, "bought with 449" – Acc.			Unknown
0460		two fluted alabaster pedestals, "bought with 449" – Acc.			Unknown
0461		pillar, "Pavonezza . . . bought from Cavaceppi" – Acc.			Unknown
0462		pillar, "Pavonezza . . . companion to above, broken in two" – Acc.			Unknown
0463		pillars, two violet brescia "from Cavaceppi" – Acc.			Unknown
0464		pillars, two Prego "bought from Mr. Thorpe" – Acc.			Unknown
0465		pillars, two fluted, "very ancient" – Acc.			Unknown
0466		pillar, "inlaid, bought with 122" – Acc.			Unknown
0467		two alabaster pedestals, "in form of two elegant vases" – Acc. Private Coll.			

Blundell's Account 1803/10	Identity Number	Description	Ashmole 1929	Michaelis 1882	Current Location
0468	0218	shaft with votive reliefs	0218	0218	Museum
0469		two wooden pillars, "bought with 457" – Acc.			Unknown
0470		pillar, Cavaceppi			Unknown
0471		pillars, two, "on them are fixed two antique hands" – Acc.			Unknown
0472		plinths, two, serpentine marble			Unknown
0473		table, grey granite, with pedestal 309			Unknown
0474		table, dove marble "bought for the hall" – Acc.			Unknown
0474		table, inlaid with marble "from sculptor in Campo Vacino, Rome 1777" – Acc.			Private Coll.
0475		tables, two "of oriental alabaster" – Acc.			Unknown
0476		table, "of pecorella marble" – Acc.			Unknown
0477		tables, two "of brocatella marble" – Acc.			Unknown
0478		tables, two "of verd antique" – Acc.			Unknown
0479		tables, two "of Verd Antique, from Pope Pius VI" – Acc.			Private Coll.
0480		tables, two, "a present from Pope Pius VI" – Acc.			Private Coll.
0481		tables, two "oriental alabaster" – Acc.			Unknown
0482		table, "of lava" – Acc.			Unknown
0483		table, jasper "bought from Mr. Hayward, statuary, in Piccadilly" – Acc.			Unknown
0485		table, "Darbyshire marble" – Acc.			Unknown
0486		vases, two of lava "formed from two antique vases" – Acc.			Unknown
0487		vases, two "green granite" – Acc.			Private Coll.
0488		vase, serpentine marble "bought from Mr. Hayward, statuary, London" – Acc.			Unknown
0489		obelisks, two "oriental Lumachella" – Acc.			Unknown
0490		vase, oblong "a kind of ferrugineous marble" – Acc.			Unknown
0491		vase, "white alabaster . . . on it a Greek inscription" – Acc.			Unknown
0492		vases, two "open, one of red & white alabaster, other of brescia" – Acc.			Unknown
0493		1059 urn, alabaster "light colour and beautifully veined" – Acc.			Museum
0494	0407	vases, three, ceramic, (not illus. Ashmole)	0407	0407	Unknown
0495	0408	vases, twelve Greek, (not illus. Ashmole)	0408	0408	Unknown
0496		inscription, "GELLIA . . . GELLIAE . . . SALVIAE" – Acc.			Unknown
0497	1024	amphora, "found in an arched vault at Pompeia" – Acc.			Museum
0497	1025	amphora, "found in an arched vault at Pompeia" – Acc.			Museum
0498	0409	lamp, bronze, modern, (not illus. Ashmole)	0409	0409	Private Coll.
0498	0498	lamp, bronze "bought from Mr. Clarke, at Naples" – Acc.			Private Coll.
0499		lamps, in terracotta "some of these were found at Pompeia" – Acc.			Unknown
0500		tear bottles, glass			Unknown
0501		medallions, plaster "portraits of the twelve Caesars" – Acc.			Unknown
0502	0502	steelyard, bronze			Private Coll.
0503		head, terracotta waterspout "bought from Piranese" – Acc.			Unknown

Blundell's Account 1803/10	Identity Number	Description	Ashmole 1929	Michaelis 1882	Current Location
0504		Egyptian pots, "black basalte and came from Egypt, holes in bottom" – Acc.			Unknown
0505		lion, "in rosso antico . . . found by the owner on the Palatine hill" – Acc.			Unknown
0506		model, plaster "Theseus & Minotaur, by Canova" – Acc.			Unknown
0507	0401	vase, (not illus. Ashmole), heavily restored by Piranesi	0401	0401	Private Coll.
0508		pitcher "terracotta, bought on the spot when found, Pozzuoli" – Acc.			Unknown
0509		hand, "Zeno's, original hand of statue in Capitoline" – Acc.			Unknown
0510		foot, female			Unknown
0511		relief, "Ariadne, draped and drawn in a car by two lions" – Acc.			Unknown
0512		vase, fragment, "figure drawn in a car by a tiger" – Acc.			Unknown
0513	0274	sarcophagus, end of, hunter lion & horse,	0274	0274	Museum
0514		pedestal, "bulla aurea on neck of lion, Villa Guistiniani" – Acc.			Museum
0515	0051	statue, portrait, female, draped, Antonine	0051	0051	Museum
0516	0036	Statue, female, semi-draped, Aphrodite	0036	0036	Museum
0517	0082	statuette, female, draped, archaistic, ?Tyche	0082	0082	Museum
0518	0011	statuette, female, archaistic, Athena	0011	0011	Museum
0519	0310	relief, three figures, "Heroes", plus fragment of arm and modern head	0310	0310	Museum
0520	0303	sarcophagus, front of, Romans in battle	0303	0303	Ince
0521	(WAG) 6535	relief, girl before round temple, ?modern	0304	0304	Gallery
0522	0215	bust, male, portrait, Trajanic	0215	0215	Museum
0523	0221	relief, front of sarcophagus, Phaethon before Helios	0221	0221	Museum
0524	0393	sarcophagus, front of, hunting scene	0393	0393	Ince
0525	0137	herm, male, portrait, bearded, philosopher	0137	0177	Museum
0525	0177	(=0137 Ashmole)	0177=0137		
0526		tables, two mosaic "well remembered in the Popes's Palace" – Acc.			Unknown
0527		tables, two mosaic "as the above slabs" – Acc.			Unknown
0528		two slabs of bianco nero			Unknown
0529	0412	mosaic, man watering cattle, top of table	0412	0412	Unknown
0530	0015	statue, male, naked, Apollo	0015	0015	Museum
0531	0025	statue, Hermaphrodite, sleeping	0025	0025	Museum
0532		pedestal, "on which stood the preceding article (531)" – Acc.			Unknown
0533	0305	altar, round, Dionysiac scenes	0305	0305	Museum
0534	0306	altar, round, deities in underworld	0306	0306	Museum
0535	0394	reliefs, inscriptions, (not illus. Ashmole), in pedestal of Ash. 2	0394	0394	Unknown
0536		urn, alabaster "shape is different from most urns" – Acc.			Unknown
0537	0353	Vase-shaped urn of Licinius Felix, C.I.L. VI 21255	0353	0353	Museum
0538		inscriptions, four "in Greek & Latin" – Acc.			Unknown
0539	0307	sarcophagus, 2 fragments of lid and 2 heads	0307	0307	Museum
0540	0395	altar, Zeus Ammon	0395	0395	Museum
0541	0083	statue group of nymph on sea-horse	0083	0083	Museum
0542	(WAG) 6532	bust, male, portrait, porphory, modern	0216	0216	Gallery
0542	(WAG) 6533	bust, male, portrait, porphory, modern	0216a	0216a	Gallery

Blundell's Account 1803/10	Identity Number	Description	Ashmole 1929	Michaelis 1882	Current Location
0543	0543	statuette, lion attacking horse, (wrong attribution by Ash. and Mich.)			Gallery
0544		pedestal, "formed of curious antique fragments (for 543)" – Acc.			Unknown
0545	0063	fragment, female, naked torso, Aphrodite	0063	0063	Museum
0546	0396	sarcophagus, two fragments of, shepherds and door of tomb	0396	0396	Museum
0547	0413	mosaic, female head, ?modern	0413	0413	Unknown
0548	0058	statue, Egyptian, Roman period	0058	0058	Museum
0549	0098	bust, male, portrait, Marcus Aurelius	0098	0098	Museum
0550		pillars, two "each 5' 1" in height" – Acc.			Unknown
0551	0371(M)	Ash chest of C. Munius Serenus	0371	0371	Museum
0552	WAG 10336	bust, male, portrait, Caracalla, modern	0217	0217	Gallery
0554	0064	statue, male, draped, seated	0064	0064	Museum
0555	0063a	torso, female, naked lower half	0063a	0063a	Museum
0556	0066	statuette, female, Aphrodite, (not illus.Ashmole)	0066	0066	Private Coll.
0557	0067	statuette, female, draped Hera(?), bronze	0067	0067	Private Coll.
0558	0012	statue, torso, male, Apollo Sauroktonos	0012	0012	Museum
0561	0561	lamp, bronze, grotesque head, modern			Private Coll.
0565	0065	statuette, Egyptian, bronze, (not illus.Ashmole)	0065	0065	Private Coll.
0566	(WAG) 9105	bust, Satyr, bronze			Gallery
0568	(WAG) 6896	torso, with head, female, fragment of statue			Gallery
0568	(WAG) 6896	statuette, boy, Eros			Gallery
0569	0050	statue, male, heroic, semi-draped with portrait, male, Hadrianic	0050		Museum
0570	0217a	bust, male, portrait, Trajanic	0217a	0217a	Museum
0571	0217b	bust, male, portrait, Trajanic general	0217b	0217b	Museum
0572	(WAG) 7491	bust, male, portrait, bronze, Seneca, modern	0217e		Gallery
0573	0217d	bust, male, portrait, ?Flavian	0217d		Museum
0574	0179a	bust, male with ivy leaves, ?Antinous/Dionysius	0179a		Museum
0575	0217f	bust, male, portrait, early Imperial	0217f		Museum
0576	0119	herm, female, archaistic	0119	0119	Museum
0577	0140	head, male, portrait, colossal, ?philosopher	0140	0140	Museum
0577	0141	head, male, portrait, colossal, ?philosopher	0141	0141	Museum
0578	0142	fragment, half of head, female	0142	0142	Ince
0578	0386	(=0142 Ashmole)	0386=0142		
0580	0083c	statuette, female, draped, Urania	0083c		Museum
0581	0397	sarcophagus, front of, two victories + bust of boy, (not illus. Ash)	0397	0397	Museum
0583	0398	sarcophagus, fragment, bust of boy, (not illus. Ashmole)	0398	0398	Museum
0585	0121a	mask, male, water god, bronze	0121a		Unknown
0586	0202b	head, boy, miniature	0202b		Unknown
0587	0587	head, male, faun, bronze, modern			Private Coll.
0588	0228	relief, front of sarcophagus, inscr. Octivius Firmus	0228	0228	Museum
0594	0212a	fragment, vessel, attachment, forepart of Satyr, bronze	0212a		Unknown
0595	0162a	bust, boy, ?archaic	0162a		Museum
0597	(WAG) 9111	bust, male, Apollo, ?modern	0145a		Gallery
0598	(WAG) 9107	bust, male, Apollo, ?modern	0145b		Gallery
0599	0217h	fragment, head, Artemis	0217h		Unknown
	(WAG) 9114	head, male, with elaborate coiffure, Bacchus			Gallery
	(WAG) 10334	head, male, Lucius Verus, modern	0084a		Gallery
	(WAG) 10339	head, female, veiled			Gallery
	0054	fragment, inscription			Museum

Blundell's Account 1803/10	Identity Number	Description	Ashmole 1929	Michaelis 1882	Current Location
	0111a	double herms, males, water gods	0111a		
	0202a	bust, boy, "doubtful genuineness" – Ashmole	0202a		Unknown
	0217g	head, small, male, Septimius Severus	0217g		Museum
	0217i	head, male, Narcissus	0217i		Unknown
	0252	relief, frieze, boys hunting stags, (not illus. Ashmole), Eng 94,1	0252	0252	Soane Museum, London
	0291	relief, fragment, votive, youth sacrificing, Eng. 114,1	0291	0291	Unknown
	1001	urn, lid			Museum
	1002	sarcophagus, corner, Cupid/Sphinx			Museum
	1004	sarcophagus, inscription			Museum
	1005	Ash altar of G. Umbricius Veientanus, C.I.L. VI 29417			Museum
	1008	relief, fragment, Cupid on horse			Museum
	1009	statuette, serpent, with mask			Museum
	1010	foot, colossal, fragment			Museum
	1011	foot, left, colossal			Museum
	1012	hands(2):1, small			Museum
	1012	hands(2):2, small			Museum
	1013	leg			Museum
	1015	foot, right (of pair)			Museum
	1015	foot, left (of pair)			Museum
	1017	plinth, with orb			Museum
	1018	hand, fragment			Museum
	1019	hand, fragment			Museum
	1020	relief, with female head at corner			Museum
	1022	sarcophagus, fragment of, reclining woman			Museum
	1023	relief, inscription, Julia Missa			Museum
	1026	foot, fragment, with sandal			Museum
	1028	fragment, inscription			Museum
	1029	fragment, urn(?)			Museum
	1031	drapery, fragments(2):2			Museum
	1031	drapery, fragments(2):1			Museum
	1032	foot, right, colossal			Museum
	1036	basin, ornamental(?)			Museum
	1037	drums, pair			Museum
	1038	plinth, rectangular			Museum
	1039	fragment, metal, inscription, S.P.Q.R., modern			Museum
	1040	relief, fragment, floral			Museum
	1041	relief, fragment, torso, Egyptian			Museum
	1042	lid, urn			Museum
	1043	lid, urn			Museum
	1044	fragment, part of statue(?)			Museum
	1045	lid, urn			Museum
	1046	lid, urn			Museum
	1047	lid, urn			Museum
	1048	lid, urn			Museum
	1050	plinth/altar, eagle beneath two columns, snake			Museum
	1051	lid, urn, with twin cornucopiae			Museum
	1052	lid, urn			Museum
	1055	lid, urn			Museum
	1056	fragment, lid, sarcophagus			Museum
	1057	fragment, lid, sarcophagus			Museum
	1060	head, male, fragment, back			Museum

Blundell's Account 1803/10	Identity Number	Description	Ashmole 1929	Michaelis 1882	Current Location

Blundell's Account 1803/10	Identity Number	Description	Ashmole 1929	Michaelis 1882	Current Location
	1061	fragment, coral, grained			Museum
	1062	fragment, relief, warrior, prostrate			Museum
	1063	relief, figure, female, offering to winged goddess			Museum
	1064	relief, two males, upholding vase			Museum
	1065	head, female			Museum
	1067	bust, male			Museum
	1068	bust, male			Museum
	1069	bust, male, with Greek inscription, Lycurgus			Museum
	1071	head, fragment, wearing winged helmet			Museum
	1072	head, fragment			Museum
	1073	foot, fragment			Museum
	1074	head, of horse, (part of 83?)			Museum
	1074	leg, fragment			Museum
	1079	bust, female, wearing cap			Museum
	nn01	relief, fragment, slab, broken			Museum
	nn02	hand, right, holding torch			Museum
	nn03	hand, left, clenching rod			Museum
	nn04	foot, left, wearing sandal			Museum
	nn05	foot, right, of child, on plinth,			Museum
	nn06	foot, left, wearing sandal			Museum
	nn07	plinth			Museum
	nn08	base, round			Museum
	nn09	hand			Museum
	nn10	base, round			Museum
	nn11	base, round			Museum
	nn12	lid, urn			Museum
	nn13	fragment			Museum
	nn14	plinth			Museum
	nn14	fragment, leg			Museum
	nn15	fragment			Museum
	nn16	fragment			Museum
	nn17	fragment			Museum
	nn18	fragment			Museum
	nn19	fragment,			Museum
	nn20	fragment,			Museum
	nn21	fragment, plinth,			Museum
	nn22	fragment,			Museum
	nn23	fragment, plinth,			Museum
	nn24	fragment, plinth,			Museum
	nn25	fragment, circular, plinth			Museum
	nn26	plinth			Museum
	nn27	fragment			Museum
	nn28	plinth			Museum
	nn29	slab, marble, broken			Museum
	nn30	plinth			Museum
	nn31	lid, urn			Museum
	nn32	plinth			Museum
	nn33	fragment, relief, arm, right, drapery, modern			Museum
	nn34	lid, urn, (with 346M)			Museum
	nn35	relief, sacrifice before altar, female deity			Museum
	nn36	slab, hollowed out			Museum
	nn37	lid, urn			Museum
	nn39	lid, urn			Museum
	nn40	urn, lid			Museum

Concordance 2:
Between Ashmole 1929 and Blundell's Account 1803/10

Ashmole 1929	Blundell's Account 1803/10	Ashmole 1929	Blundell's Account 1803/10	Ashmole 1929	Blundell's Account 1803/10	Ashmole 1929	Blundell's Account 1803/10	Ashmole 1929	Blundell's Account 1803/10
0001	0056	0044	0049	0083b	0432	0115	0151	0153	0119
0002	0004	0045	0033	0083c	0580	0116	0144	0154	0123
0003	0010	0046	0036	0083d	0072	0117	0128	0155	0127
0004	0018	0047	0053	0083e	0421	0118	0145	0156	0131
0005	0039	0048	0006	0083f	0434	0119	0576	0157	0133
0006	0022	0049	0024	0083g	0431	0120	0147	0158	0136
0007	0054	0050	0569	0083h	0426	0121	0172	0159	0137
0008	0001	0051	0515	0084	0090	0121a	0585	0160	0339
0009	0008	0052	0007	0084a		0122	0149		/0227
0010	0013	0053	0059	0085	0091	0123	0157	0161	0140
0011	0518	0054	0011	0086	0092	0124	0158	0162	0141
0012	0558	0055	0027	0087	0093	0125	0159	0162a	0595
0013	0012	0056	0058	0088	0094	0126	0163	0163	0142
0014	0076	0057	0078	0089	0097	0127	0189	0164	0148
0015	0530	0058	0548	0089	0104	0128	0336	0165	0153
0016	0052	0059	0086		=0097	0129	0190	0166	0154
0017	0074	0060	0077	0090	0105	0130	0212	0167	0155
0018	0023	0061	0191	0091	0108	0131	0213	0168	0166
0019	0019	0062	0338	0092	0165	0132	0305	0169	0167
0020	0005	0063	0545	0093	0107	0133	0182	0170	0168
0021	0029	0063a	0555	0094	0130	0134	0209	0171	0169
0022	0002	0064	0554	0095	0109	0134a	0210	0172	0170
0023	0037	0065	0565	0096	0110	0135	0300	0173	0173
0024	0020	0066	0556	0097	0126	0136	0211	0174	0174
0025	0531	0067	0557	0098	0549	0137	0525	0175	0176
0026	0032	0068	0021	0099	0117	0138	0229	0176	0177
0027	0031	0069	0069	0100	0118	0139	0098	0177	0525
0028	0030	0070	0070	0101	0115	0140	0577		=0137
0029	0034	0071	0035	0102	0114	0141	0577	0178	0180
0030	0075	0072	0050	0103	0177	0142	0578	0179	0187
0031	0014	0073	0061		=0176	0143	0164	0179a	0574
0032	0073	0075	0079	0104	0120	0144	0122	0180	0188
0033	0038	0076	0080	0105	0171	0145	0095?	0181	0193
0034	0015		=0041	0106	0152	0145a	0597	0182	0194/5
0035	0057	0077	0085	0107	0129	0145b	0598	0183	0195/4
0036	0516	0078	0087	0108	0150	0146	0096	0184	0196
0037	0016	0079	0088	0109	0132	0147	0097	0185	0197
0038	0051	0080	0089	0110	0192		=0089	0186	0198
0039	0055		=0238a	0111	0146	0148	0106	0187	0199
0040	0028	0081	0160	0111a		0149	0111	0188	0200
0041	0080?	0082	0517	0112	0226	0150	0112	0189	0201
0042	0009	0083	0541	0113	0143	0151	0113	0189a	0064
0043	0003	0083a	0433	0114	0156	0152	0116	0190	0202

Ashmole 1929	Blundell's Account 1803/10	Ashmole 1929	Blundell's Account 1803/10	Ashmole 1929	Blundell's Account 1803/10	Ashmole 1929	Blundell's Account 1803/10	Ashmole 1929	Blundell's Account 1803/10
0191	0203	0227	0331	0278	0284	0332#	0369	0383	0300
0192	0204	0228	0588	0279	0285	0333#	0364	=0135	
0193	0205	0229	0341	0280	0333	0334#	0366	0384	0301
0194	0206	0230	0372	0281	0318	0335	0360	0385	0302
0195	0214	0231	0365	0282	0287	0336#	0363	0386	0578
0195	0225	0232	0342	0283	0292	0337#	0379	=0142	
0196	0215	0233	0343	0284	0291	0338#	0412	0387	0305
0197	0216	0234	0355	0285	0312	0339#	0378	0388	0306
0198	0217	0235	0397	0286	0327	0340	0401	0389	0310
0199	0218	0236	0354	0287	0328	0341#	0367	0390	0317
0200	0219	0237	0407	0288	0313	0342#	0382	0391	0335
0201	0220	0238	0408	0289	0322	0343#	0391	0392	0340
0202	0221	0238a	0089	0290	0314	0344#	0399	0393	0524
0202a		0239	0409	0291		0345#	0384	0394	0535
0202b	0586	0240	0376	0292	0084	0346#	0389	0395	0540
0203	0175	0241	0237	0293	0316	0347#	0386	0396	0546
0204	0223	0242	0289	0294	0316	0348#	0380	0397	0581
0205	0195	0243	0238	0295	0320	0349#	0388	0398	0583
0205a	0195	0244	0246	0296	0323	0350#	0390	0399	0307
0206	0160	0245	0404	0297	0325	0351#	0387	0400	0308
0207	0228	0246	0239	0298	0326	0352#	0375	0401	0507
0208	0230	0247	0241	0299	0329	0353#	0537	0402	0440
0209	0184	0248	0242	0300	0330	0354#	0348	0403	0442
0210	0232	0249	0243	0301	0334	0355#	0349	0404	0270
0211	0233	0250	0245	0302	0402	0356#	0350	0405	0400
0212	0234	0251	0244	0303	0520	0357#	0362	0406	0418?
0212a	0594	0252		0304	0521	0358#	0395	0407	0494
0213	0169	0253	0247	0305	0533	0359#	0416	0408	0495
=0171		0254	0311	0306	0534	0360#	0346	0409	0498
0214	0410	0255	0283	0307	0539	0361#	0347	0410	0252
0215	0522	0256	0250	0308	0319	0362#	0374	0411	0448
0216	0542	0257	0251	0309	0321	0363#	0377	0412	0529
0216a	0542	0258	0253	0310	0519	0364	0403	0413	0547
0217	0552	0259	0263	0311#	0368	0365#	0405		
0217a	0570	0260	0254	0312	0358	0366#	0406		
0217b	0571	0261	0266	0313#	0344	0367	0413		
0217c	0215	0262	0256	0314#	0361	0368#	0414		
=0196		0263	0255	0315#	0351	0369#	0415		
0217d	0573	0264	0258	0316#	0394	0370#	0417		
0217e	0572	0265	0257	0317#	0352	0371#	0551		
0217f	0575	0266	0286	0318#	0393	0372	0269		
0217g		0267	0264	0319#	0396	=0195			
0217h	0599	0268	0324	0320#	0385	0373	0274		
0217i		0269	0278	0321#	0353	0373a	0275		
0218	0468	0269a	0265	0322#	0392	0374	0275		
0219	0207	=0270		0323#	0371	0375	0276		
0219a	0208	0270	0279	0324#	0373	0376	0281		
0220	0279	0271	0272	0325#	0381	0377	0282		
0221	0523	0272	0273	0326#	0356	0378	0288		
0222	0186	0273	0345	0327#	0357	0379	0290		
0223	0240	0274	0513	0328#	0398	0380	0294		
0224	0249	0275	0277	0329#	0383	0381	0296		
0225	0332	0276	0260	0330#	0370	0382	0297		
0226	0411	0277	0280	0331	0359				

PLATES

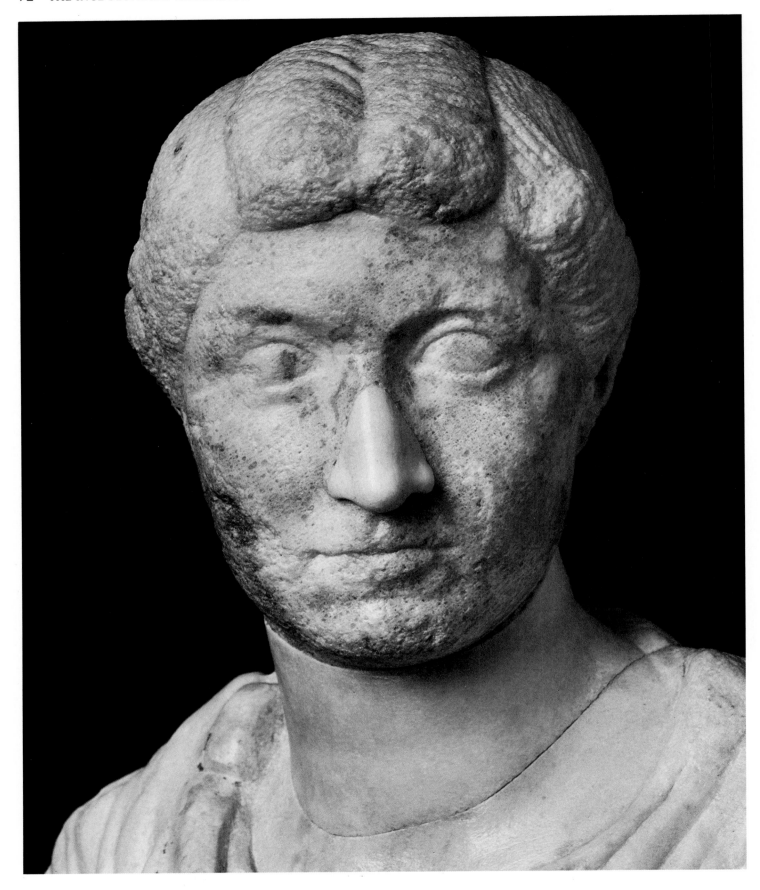

Plate 1. *Cat. no.1. Ince 35.*

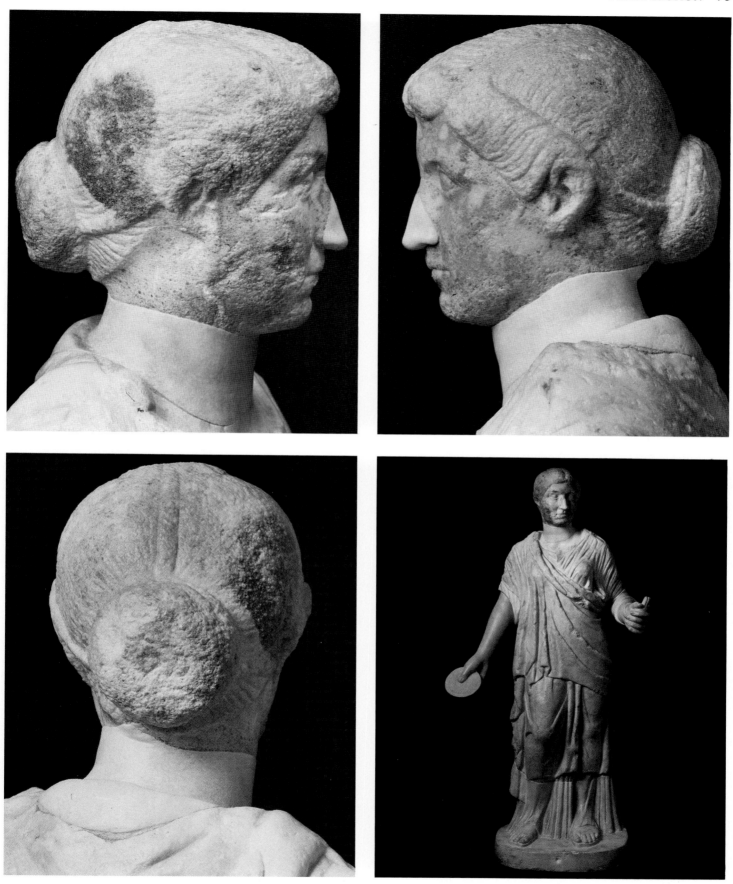

Plate 2a–d. *Cat. no.1. Ince 35.*

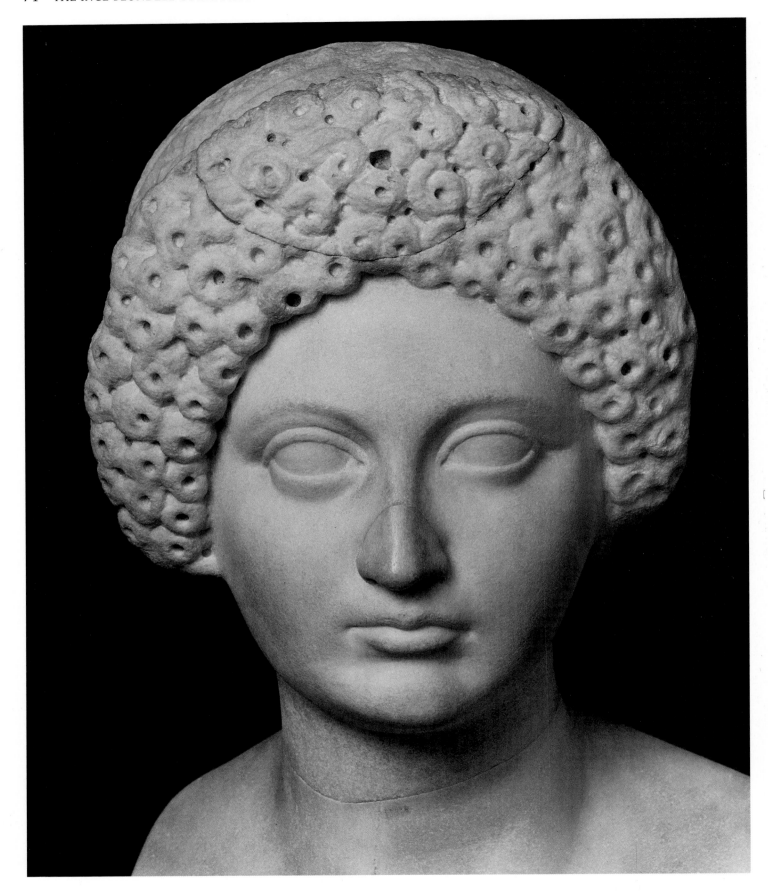

Plate 3. *Cat. no.2. Ince 120.*

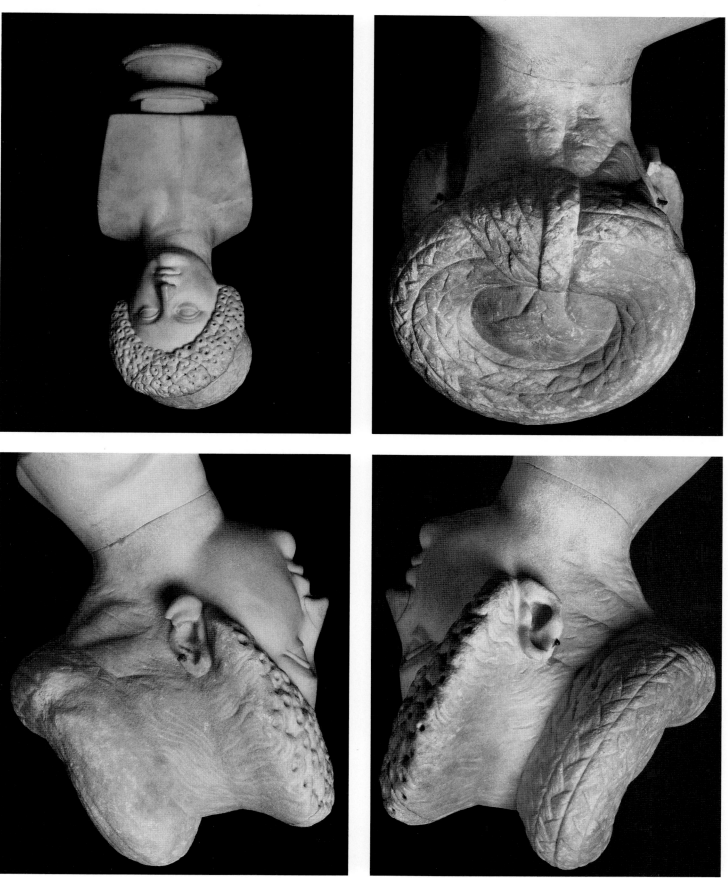

Plate 5. Cat. no.3. Ince 226.

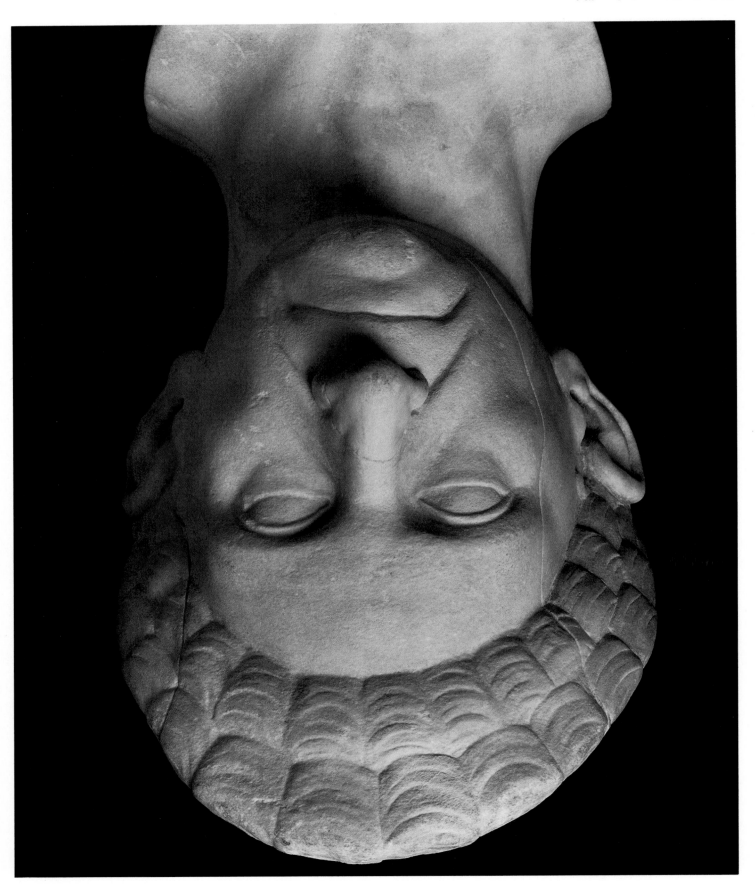

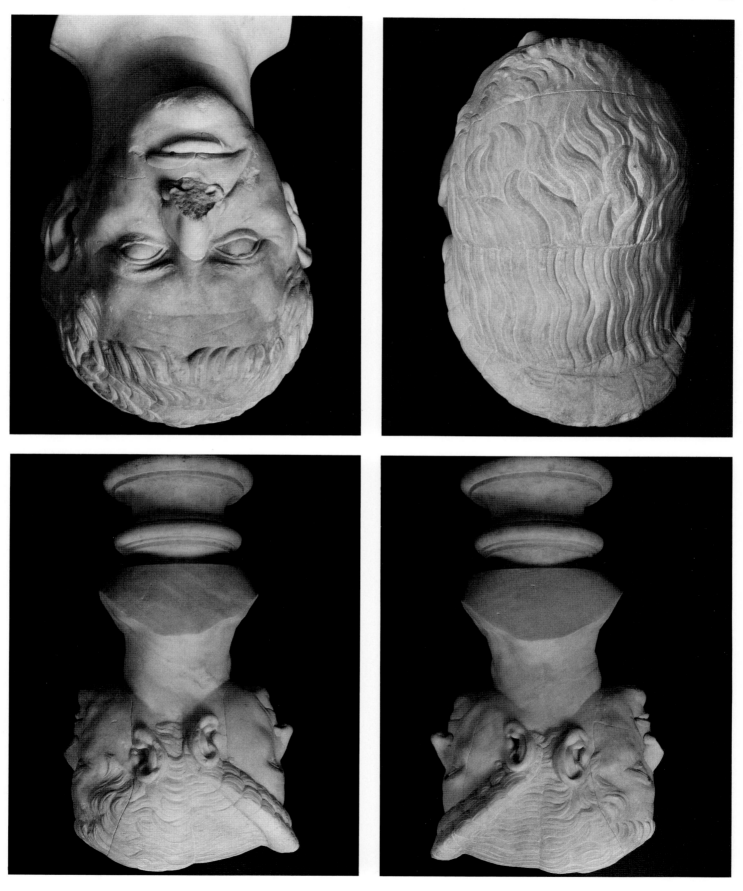

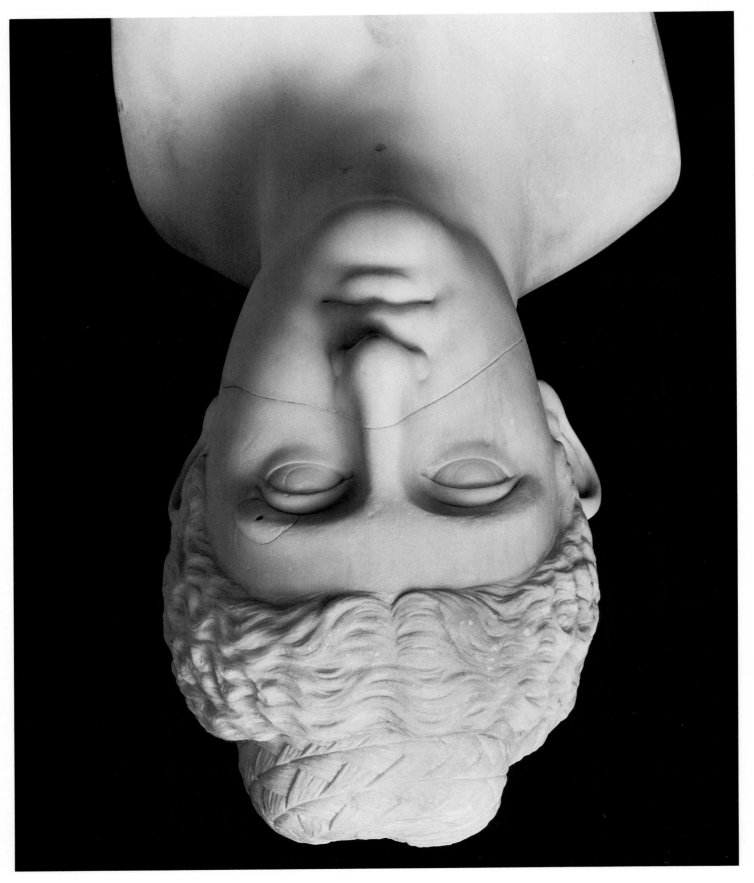

Plate 7. Cat. no.4. Ince 132.

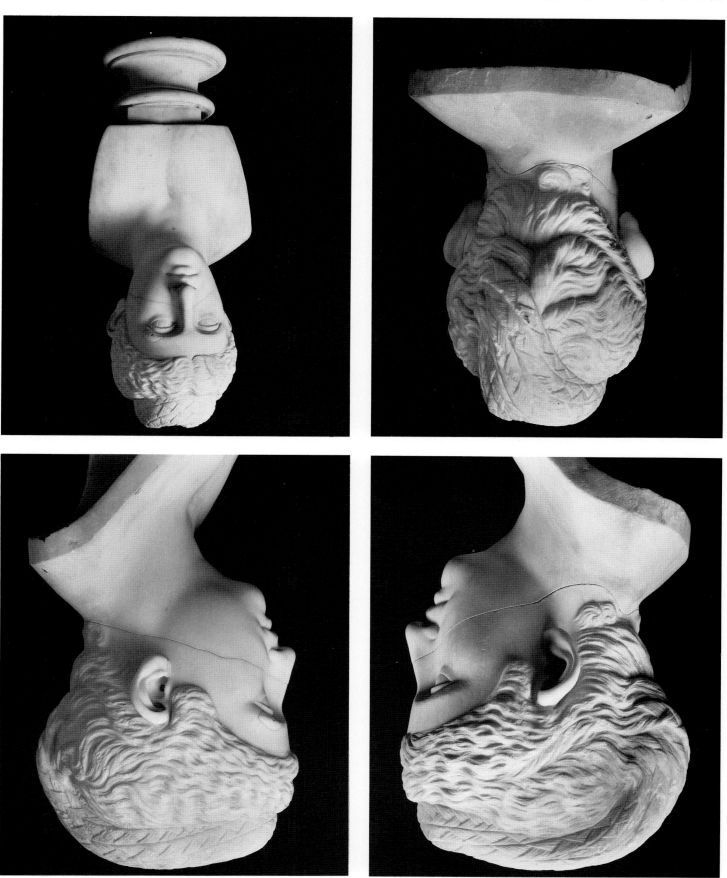

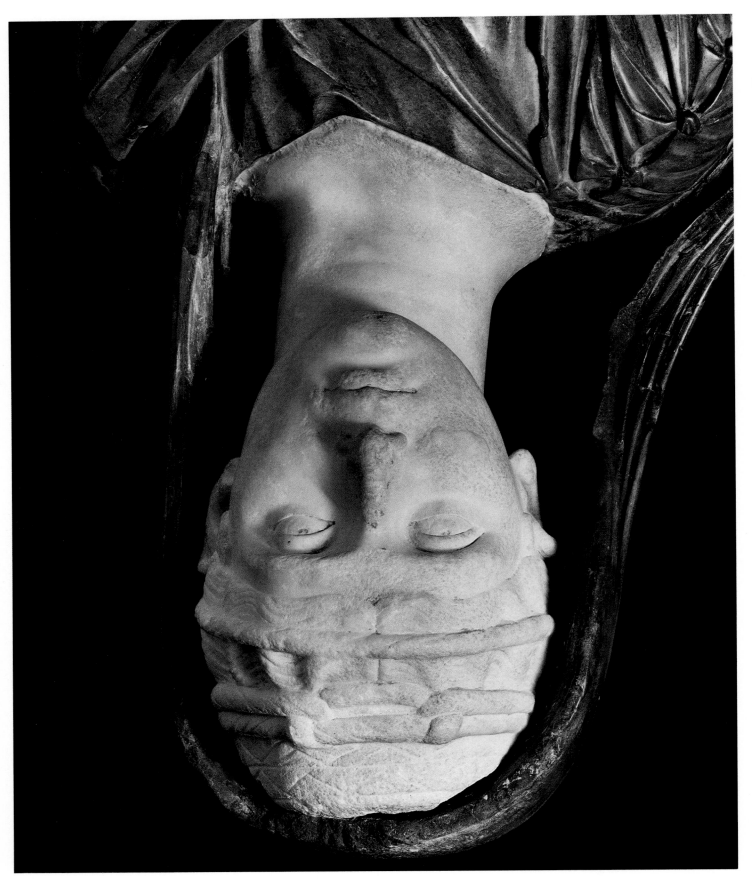

Plate 9. Cat. no.5. Ince 515.

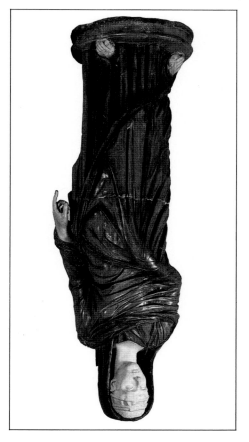
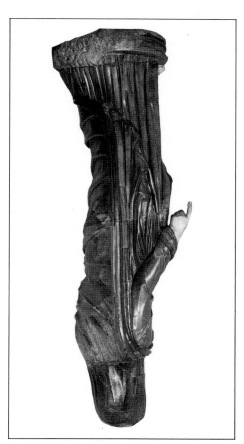
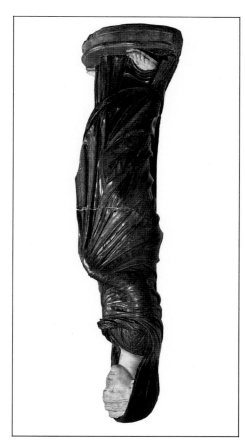

Plate 10a–e. Cat. no.5. Ince 515.

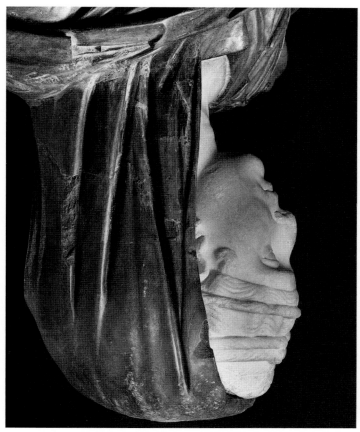
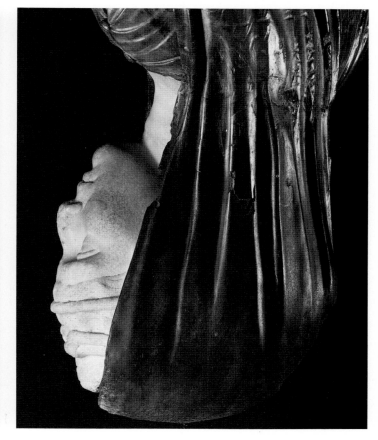

Plate 11. Cat. no.6. Ince 54.

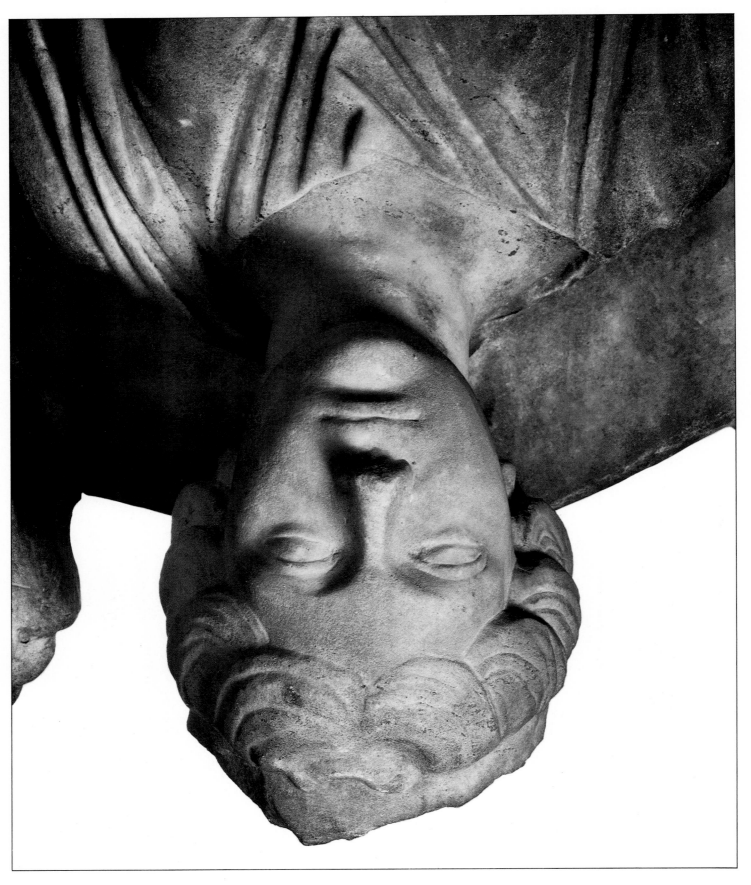

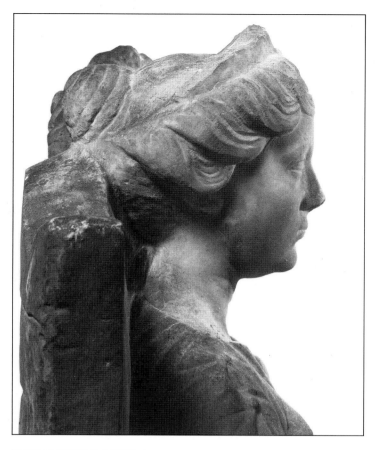
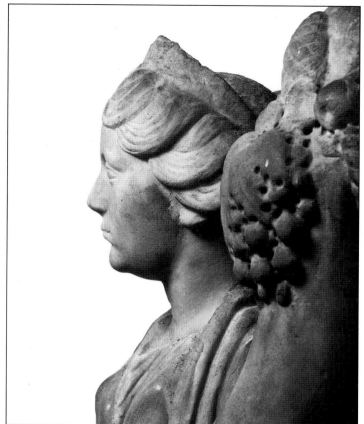
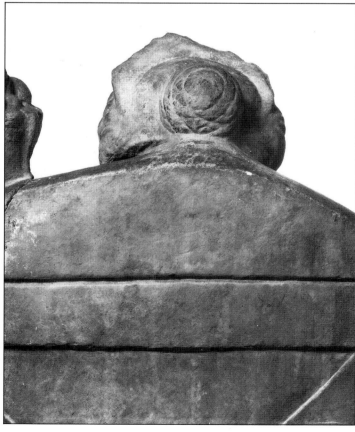

Plate 12a–d. Cat. no.6. Ince 54.

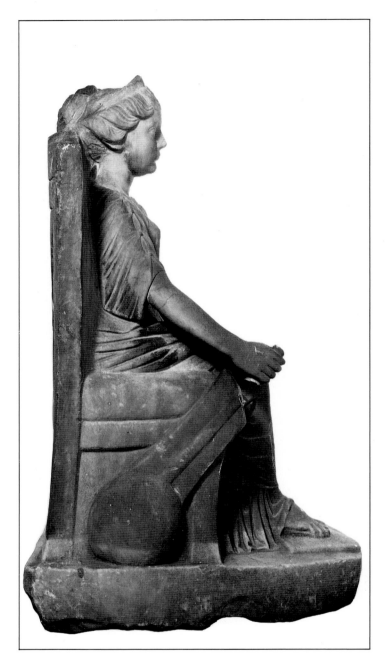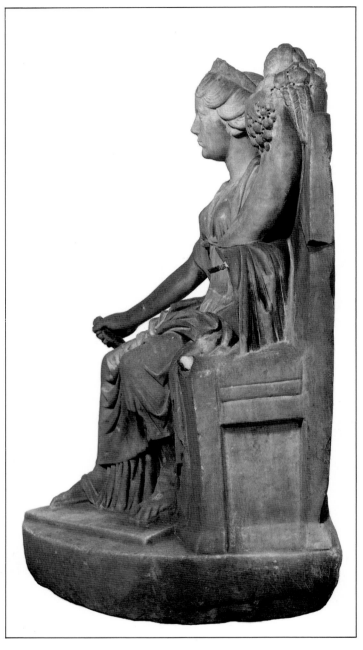

Plate 13a–b. Cat. no.6. Ince 54.

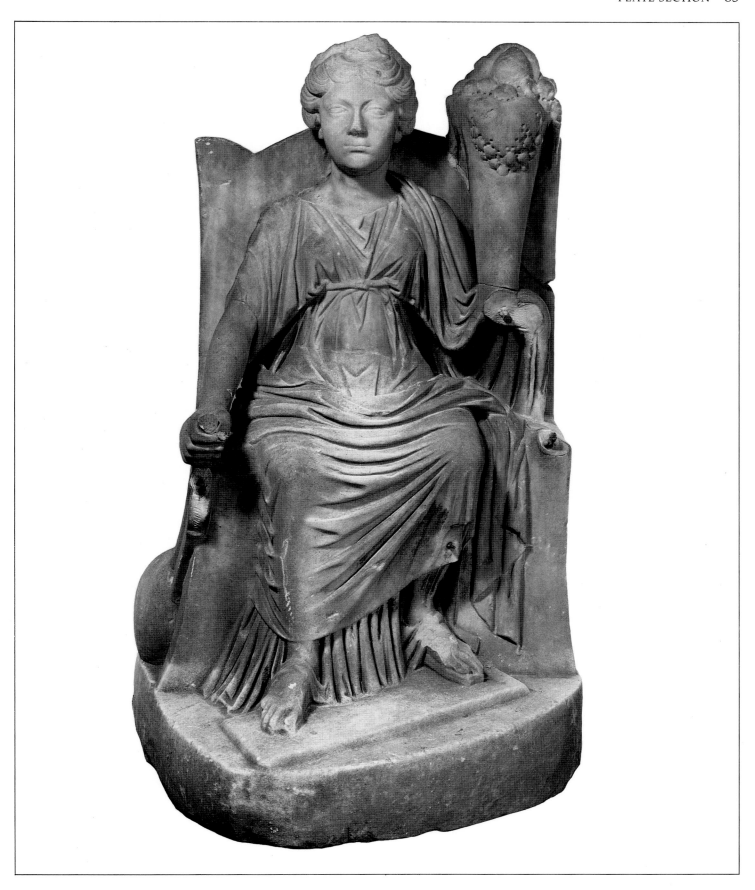

Plate 13c. *Cat. no.6. Ince 54.*

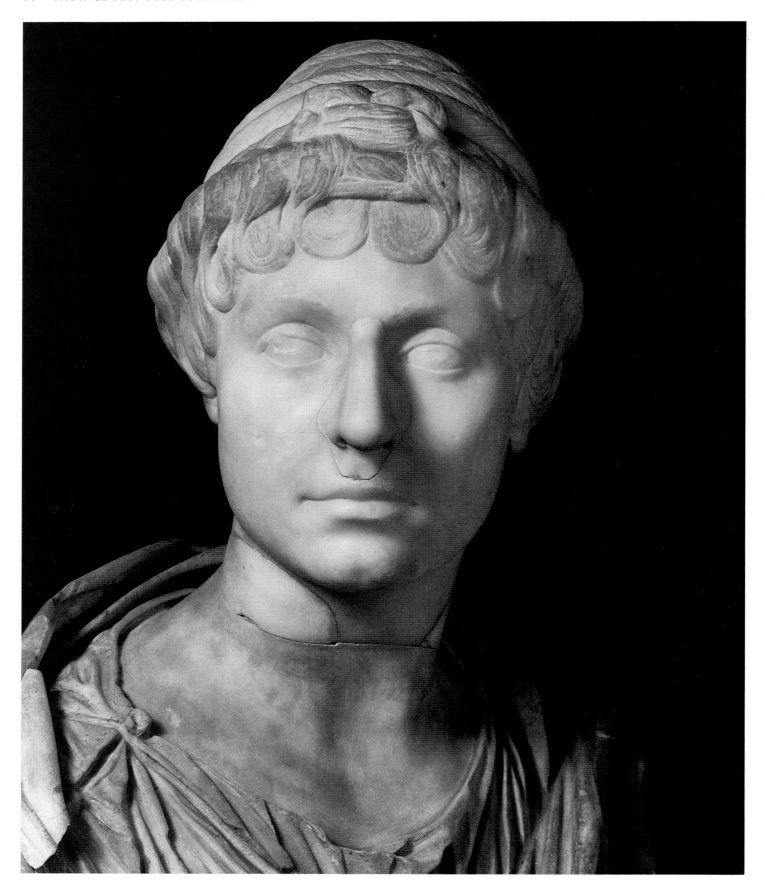

Plate 14. *Cat. no.7. Ince 108.*

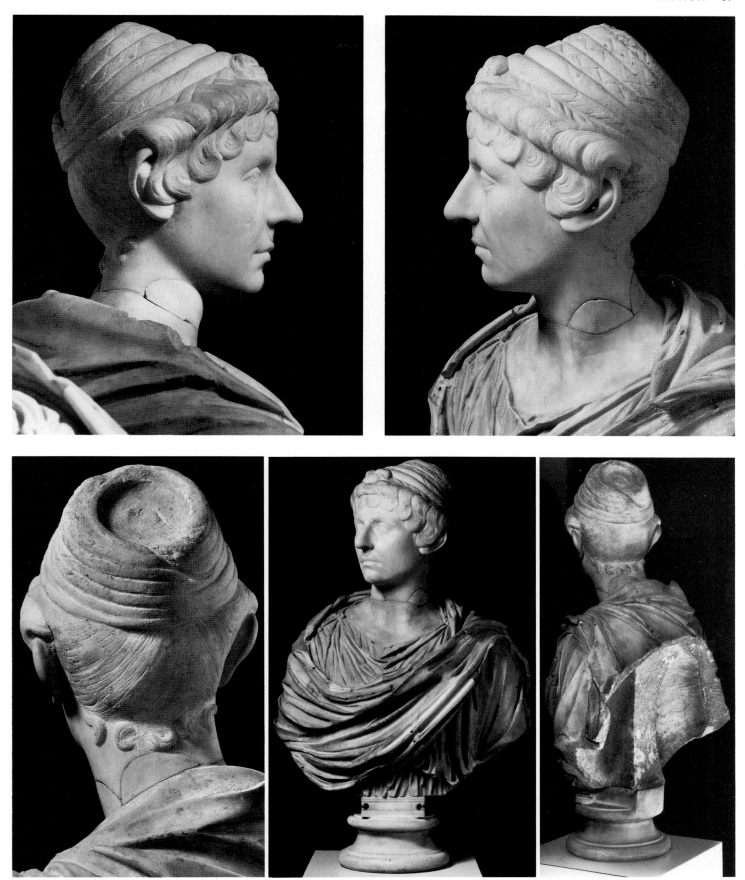

Plate 15a–e. *Cat. no.7. Ince 108.*

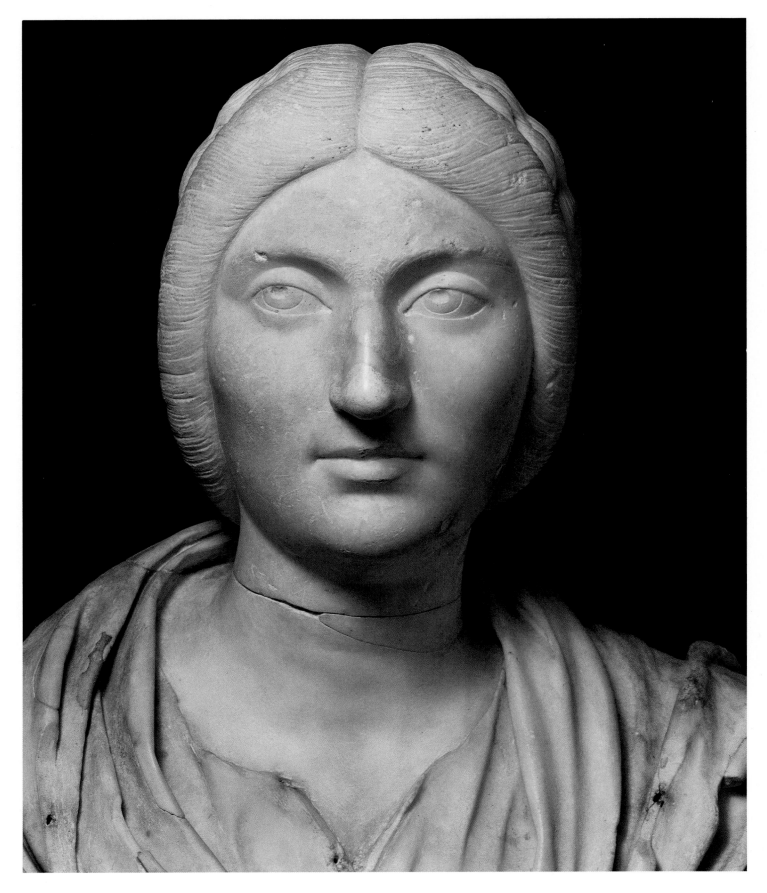

Plate 16. *Cat. no.8. Ince 107.*

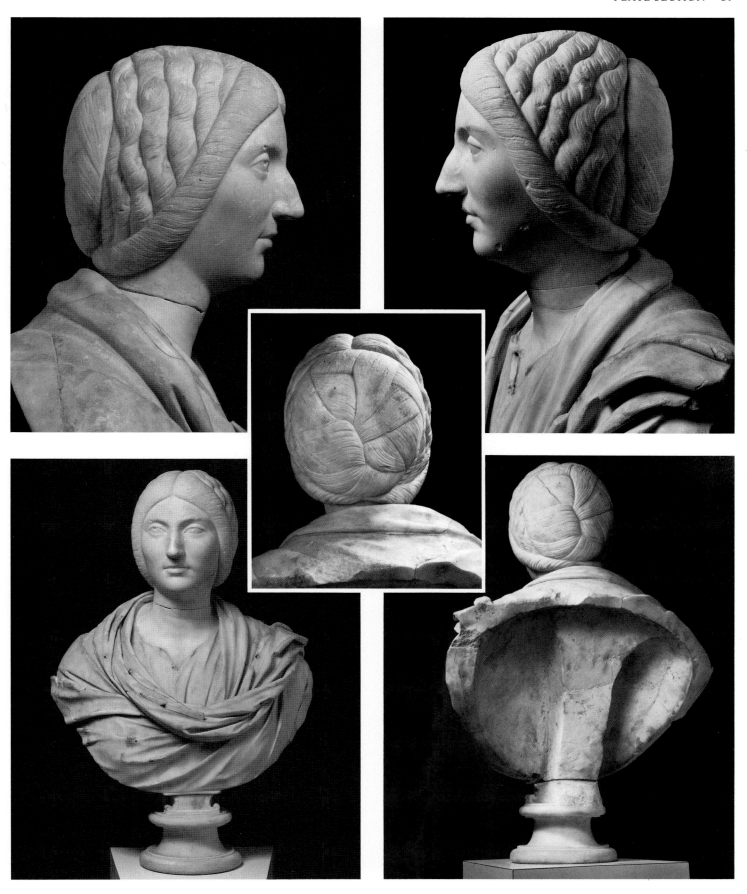

Plate 17a–e. *Cat. no.8. Ince 107.*

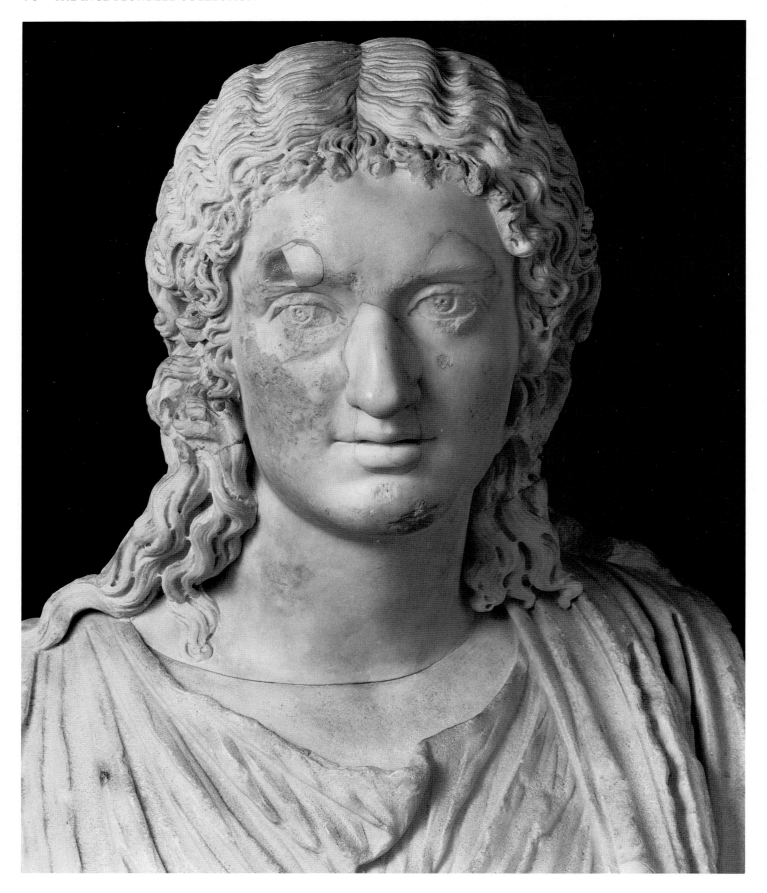

Plate 18. *Cat. no.9. Ince 7.*

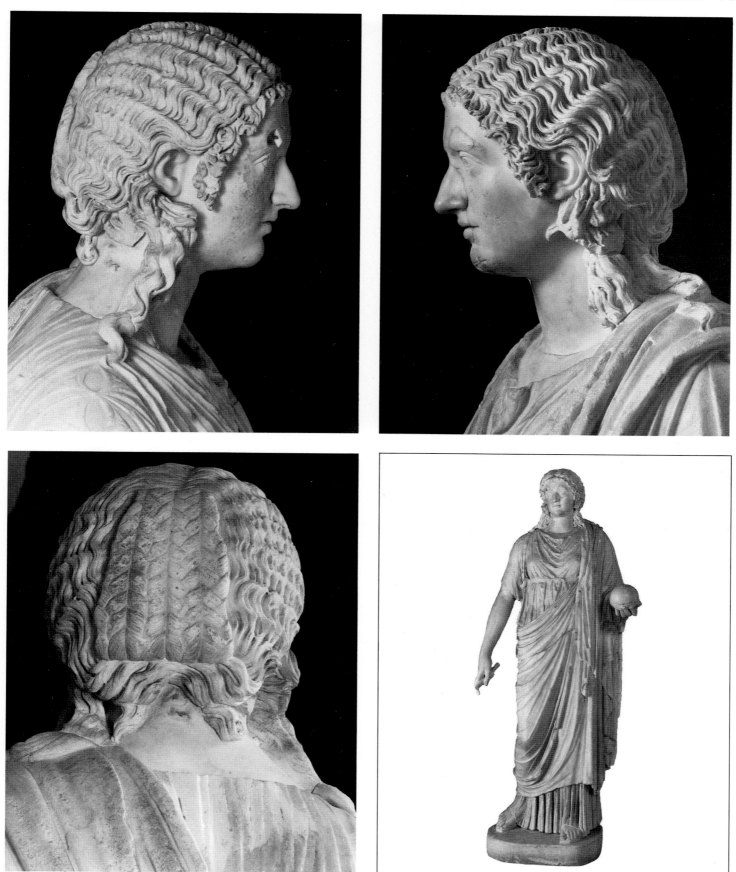

Plate 19a–d. Cat. no.9. Ince 7.

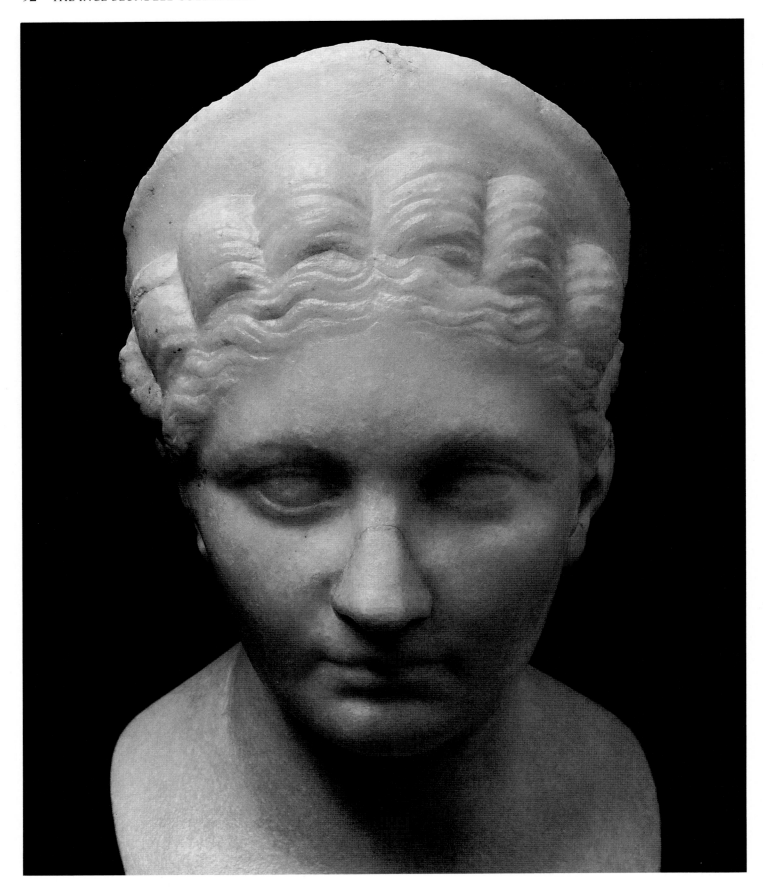

Plate 20. *Cat. no.10. Ince 115.*

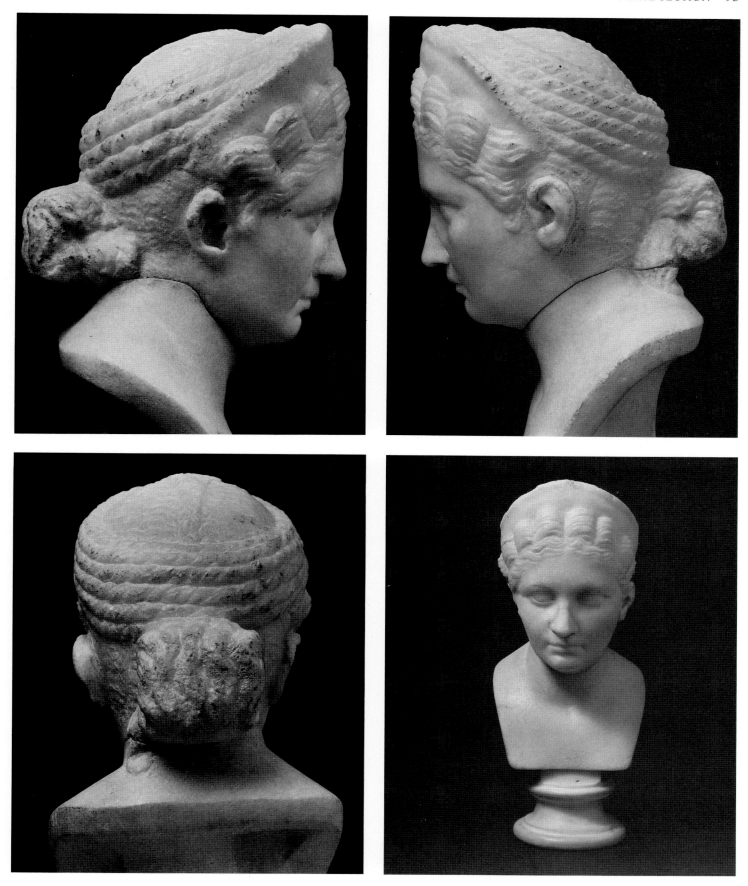

Plate 21a–d. *Cat. no.10. Ince 115.*

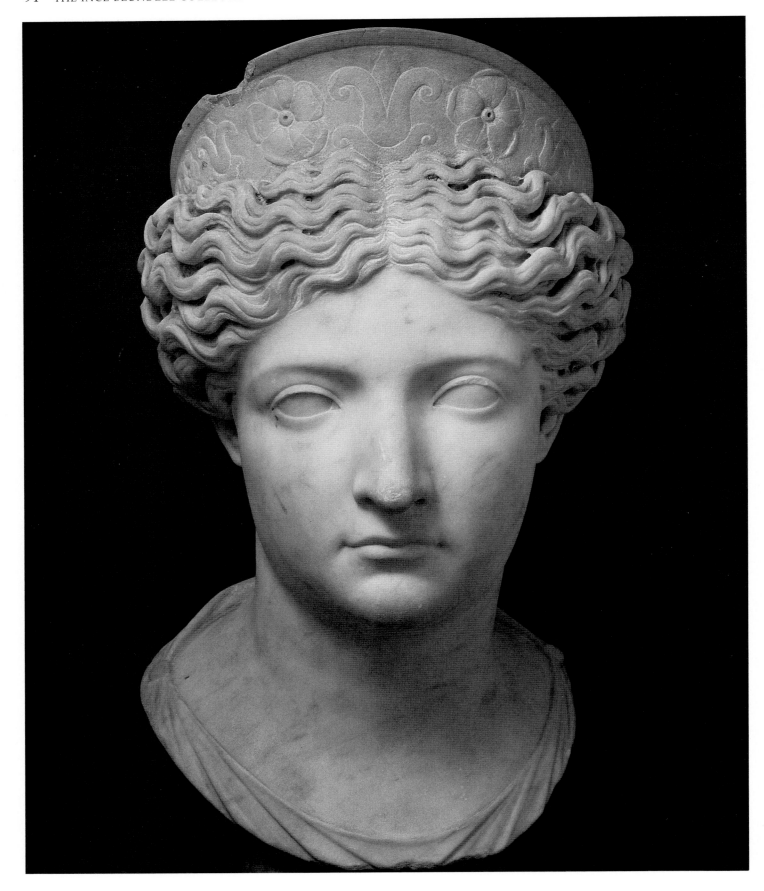

Plate 22. *Cat. no.11. Ince 164.*

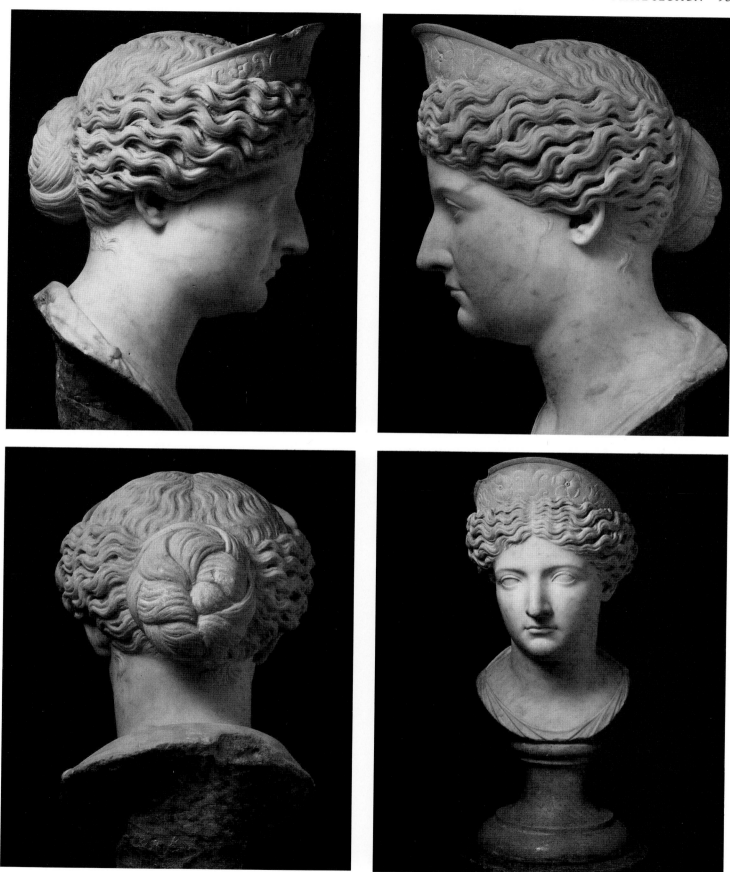

Plate 23a–d. *Cat. no.11. Ince 164.*

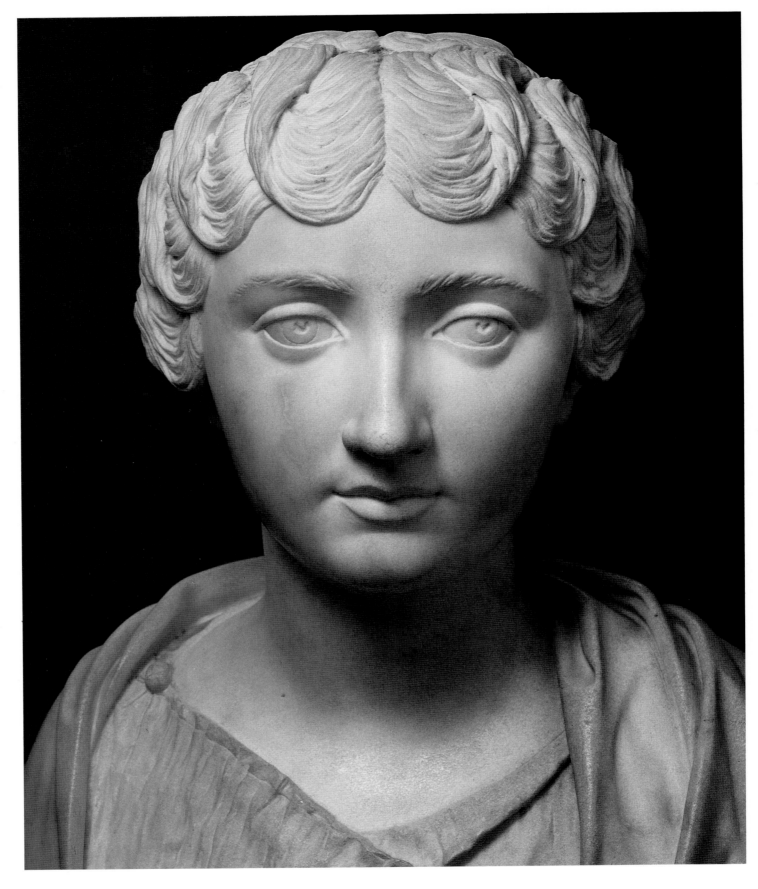

Plate 24. *Cat. no.12. Ince 201.*

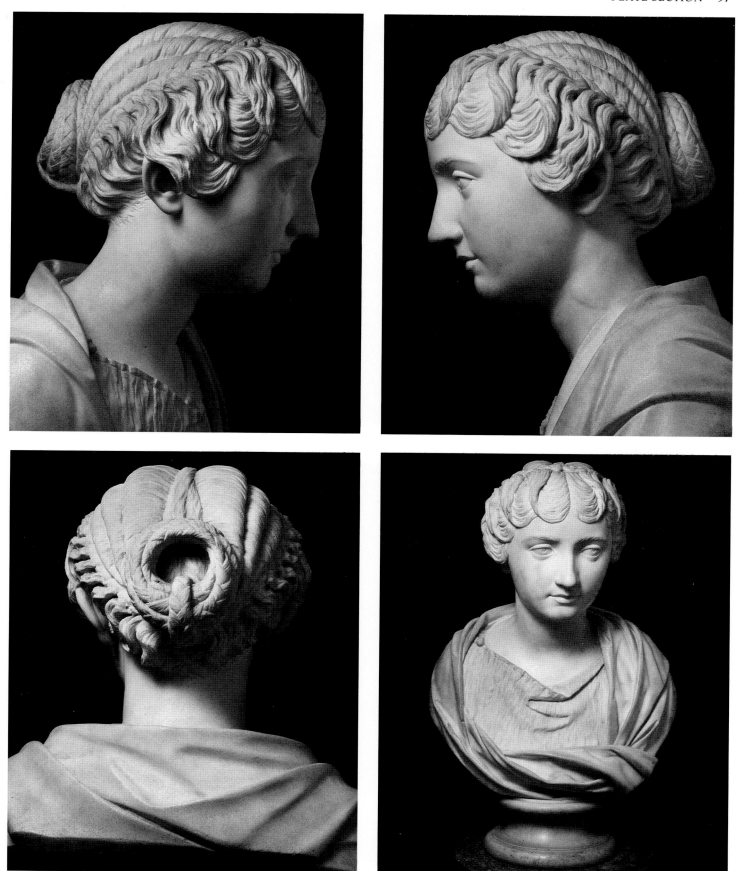

Plate 25a–d. *Cat. no.12. Ince 201.*

Printed in the United Kingdom for HMSO
Dd 291110 C10 1/91 44601